D0162288

THE STANFORD MUSEUM CENTENNIAL HANDBOOK

◆

100 YEARS
100 WORKS OF ART

Stanford University Museum of Art
Stanford, California

STANFORD
CENTENNIAL

A Stanford Centennial Publication
1891–1991

Copyright © 1991 by the Board of Trustees of the
Leland Stanford Junior University

Edited by Fronia W. Simpson. Photography by Schopplein Studio.
Designed by Marquand Books, Inc., Seattle. Photocomposed by
Trufont Typographers, Inc., Hicksville, New York. Printed in Japan
by Toppan Printing Co., Ltd.

Library of Congress Catalog Card Number: 90-72067
ISBN: 0-937031-00-3 (softcover)

Cover: Joseph Wright of Derby, *Vesuvius from Posillipo by Moonlight*,
detail (see p. 78)

CONTENTS

FOREWORD

This Centennial Handbook marks one hundred years of collecting works of art for Stanford University. Art at Stanford began in 1891 when Leland and Jane Stanford laid the Museum's cornerstone, etched with their son's birth date of May 14. Young Leland, who died of typhoid fever at the age of fifteen, had been unusually curious about objects and was an avid collector and museum goer. Deeply grieved by the death of their only child, his parents founded both the University and the Museum in his memory. The Museum was the first to be established west of the Mississippi and for a brief moment, before the 1906 earthquake destroyed large portions of it, the largest museum building in the country.

While both Stanfords participated in the cornerstone ceremony, the Museum was preeminently the vision of Jane Stanford. It was she who supervised the construction of the core building in 1891 and the spacious additions of 1898 and 1902. Given her temperament and determination, she functioned as the Museum's first director, building collections of classical antiquities, ethnographic materials, Japanese art, and contemporary paintings until her death in 1905.

In honor of the University's centennial, and of Jane Stanford's pivotal role in establishing the fine arts on this campus, this handbook surveys one hundred important works from the Museum's collection, one for each year of the institution's existence. While providing a glimpse into the richness of Stanford's collections, the handbook also gives a brief chronology of the Museum's fascinating history. This story begins with the founders' vision of a grand temple for art on the West Coast and ends with the Loma Prieta earthquake of 1989, which has compelled the rebuilding and refounding of the Museum in its hundredth year.

Beginning with the Mortimer C. Leventritt gift in 1940 of eighteenth-century Venetian and Chinese art, the collection began to expand in new directions. Other noteworthy gifts have continued to enhance the quality and breadth of the collection, especially during the last twenty-five years when Lorenz Eitner's knowledgeable leadership transformed the Museum into a modern teaching and exhibiting facility with a systematic acquisition program. During these same years, Albert Elsen has been instrumental in developing a public sculpture

program on campus, most particularly the B. Gerald Cantor Sculpture Garden of works by Auguste Rodin, the latest of many splendid gifts from Mr. and Mrs. Cantor.

Offering works of art in all media and periods, from the East as well as the West, the Museum today is an excellent teaching resource and is treasured by students, faculty, and members of the community. While old and venerable, the Museum is also young and energetic as it looks forward to a strengthened and renovated building and its second century of life.

◆

For underwriting the costs of this handbook, we would like to thank the Stanford University Centennial Operating Committee, the School of Humanities and Sciences, the Committee for Art, the Contemporary Collectors Circle, Jane Bush (A.B. 1950) Miller, and Sam Miller (A.B. 1951). Selections of the works were made by the Museum's curatorial staff in consultation with faculty members in the Department of Art. Many writers and scholars at Stanford are to be thanked for their contributions, among them, Lorenz Eitner, Albert E. Elsen, John LaPlante, Dwight Miller, Anita Mozley, Mark Munn, Mary Lou Zimmerman Munn, Melinda Takeuchi, and Richard Vinograd.

The majority of the entries were written by the Museum's curators: Carol M. Osborne, associate director and curator of collections; Betsy G. Fryberger, curator of prints and drawings; Patrick J. Maveety, curator of Asian art; Ruth Franklin, acting curator of African and Oceanic art; and by Laura Kupperman, a Stanford graduate student in the history of photography. Dr. Osborne also prepared the chronology and served as general editor of the entire project. We gratefully acknowledge all of their contributions, along with those of Joe Schopplein, photographer; Alicia Miller, who prepared the text; Fronia W. Simpson, who not only edited the writing but also provided several entries; and Ed Marquand, who has produced this publication.

Wanda Corn
Acting Director, Stanford Museum,
and Chair, Department of Art

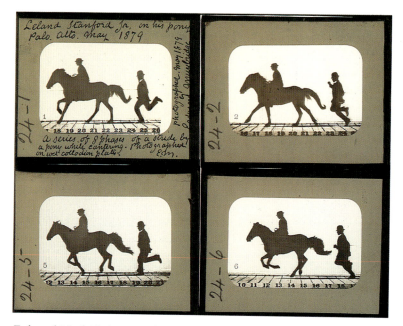

Eadweard Muybridge's image of Leland Stanford Junior on his pony, taken on May 18, 1879, at the Stanfords' country estate in Palo Alto, served to show the phases of a cantering horse in Muybridge's famous series The Horse in Motion. Stanford University is a major repository of photographs by Muybridge.

1884 March 13: Leland Stanford Junior dies in Florence. His parents resolve to found an encyclopedic museum and a university in memory of their only child. The nucleus of the Museum's collection is to be the group of ancient Egyptian, Greek, and Roman objects young Leland had gathered on visits to Paris, Athens, and Rome.

In May Leland and Jane Stanford augment the Leland Stanford Junior collection with the purchase of approximately 5,000 objects excavated on the island of Cyprus by Luigi Cesnola, director of the Metropolitan Museum of Art. These date from the Early Bronze Age to Roman times.

1885 November 11: The founding grant of the Leland Stanford Junior University and Museum is signed. The Stanfords initially thought to build the Museum in the City of San Francisco; later, they decide to locate it in Palo Alto, near the new University.

1891 May 14: The Museum's cornerstone is laid, on Leland Junior's birthday. Construction is completed in time for the opening of the University in November. Working closely with Jane Stanford, the San Francisco architects George Washington Percy and F. F. Hamilton collaborate with Ernest J. Ransome, the pioneering engineer responsible for the use of reinforced concrete in the central block. Unlike the Romanesque architecture of the quad,

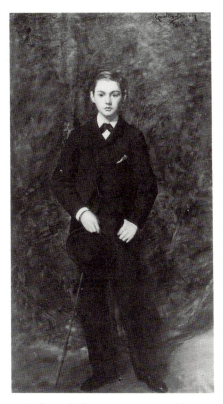

Leland Stanford Junior was portrayed by Carolus-Duran, John Singer Sargent's teacher, in his Paris studio during the Stanfords' first visit abroad in 1881.

the Museum is designed as a neoclassical building in emulation of the National Archeological Museum in Athens, where the three Stanfords once spent a day with the famous archeologist Heinrich Schliemann.

1892 The Anna M. Hewes collection of ancient Egyptian and contemporary

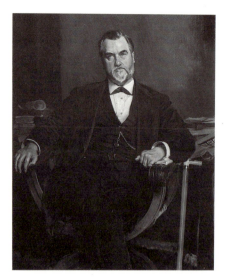

Leland Stanford had just arrived in Paris in May 1881 with Muybridge's autograph copy of Attitudes of Animals in Motion *when this portrait was painted by the French realist Meissonier. So impressed was he by the "scientific" confirmation of the stride of a galloping horse that he included the photos in the portrait.*

European art is presented to the Museum by David Hewes in memory of his wife, the sister of Jane Stanford. Included in the gift was the Last Spike, which was commissioned by Hewes and used in the ceremony that marked the joining of the eastern and western sections of the transcontinental railroad in 1869, when Leland Stanford was president of the Central Pacific Railroad.

1893 June 21: Governor Leland Stanford dies.

1894 The Leland Stanford Junior Museum is opened to the public with Jane Stanford as director in all but name. Since the death of her son, she has added more than 15,000 objects to the memorial collection. These include the Cesnola Cypriot terra-cottas and marbles; the Delong collection of Japanese objects; Eugene M. Van Reed's album of 187 Japanese *surimono* prints; Greek vases and sculptures chosen by Athanasios Rhousopoulos, a classical scholar; Northwest Coast American Indian objects collected by John Daggett and exhibited at the World's Columbian Exposition in Chicago in 1893; a large number of Korean objects gathered by Henry G. Appenzellar, a Methodist missionary; and a sizable group of Coptic textiles assembled by the British Egyptologist Sir William Flinders Petrie and presented to the Museum by Timothy Hopkins, the adopted son of Mark Hopkins and a close friend of the Stanfords.

The Stanford family collection of American paintings by artists active in San Francisco during the 1870s—among them, Albert Bierstadt, Thomas Hill, William Keith, Norton Bush, Enoch Wood Perry, and Charles Christian Nahl—is moved from the San Francisco mansion to the Palo Alto museum together with contemporary paintings by French, German, and Italian artists. Also included are portraits of the three Stanfords by Léon Bonnat, a portrait of Governor Stanford by Jean-Louis-Ernest Meissonier, and one of Leland Stanford Junior by Carolus-Duran.

The Museum's collections are used by Stanford students in conjunction with lectures given by Walter Miller, the University's first professor of Latin and Archeology.

1897 Thomas Welton Stanford, Governor Stanford's brother who emigrated to Melbourne, sends the first of three gifts of paintings to the Museum.

1898 The Museum's central building

is extended by north and south wings, and the first set of rotundas is added.

1900 Timothy Hopkins enlists in the London-based Egypt Exploration Society, and over the next eleven years ancient objects excavated at Abydos, Deir el-Bahari, Ehnasya, and Oxyrhynchus are sent to the Museum as gifts of the society.

1901 On Jane Stanford's first visit to Egypt, she buys some 300 ancient objects en bloc from two collections formed by the Cairo dealer N. D. Kyticas and the German Egyptologist Emil Brugsch, curator of the Cairo Museum.

1902 An introductory trip to Japan for Jane Stanford results in the purchase of Chinese and Japanese objects for the Museum and an acquaintance with the collector-dealer Seisuke Ikeda.

Jane Stanford commissions from the Venetian mosaic and glassmaking firm Salviati and Company eight mosaic panels to decorate the Museum's facade.

1902–06 The Museum building is extended to form a full rectangle, incorporating a second set of rotundas. The completed structure comprises 300,000 square feet and is built of ordinary brick and mortar construction, not reinforced concrete like the central block.

1904 On Jane Stanford's second visits to Egypt and Tokyo, additional collections are purchased. After returning to San Francisco, she acquires the Ikeda collection of Japanese and Chinese art.

1905 February 28: Jane Stanford dies.

Thomas Welton Stanford sends 83 paintings by nineteenth-century Australian, European, and American painters to the Museum.

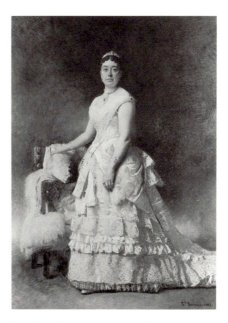

Jane Stanford wears some of her famous jewelry in the Paris portrait of 1881 by Bonnat.

1906 April 18: The San Francisco earthquake destroys all but the original 1891 central portion of the Museum and the block behind it to the west, along with much of the collection. In the aftermath of the quake, fire destroys the Stanfords' Nob Hill house and the old master paintings that had not yet been moved to Palo Alto.

1906–17 Museum curator Harry Peterson salvages, reorganizes, and inventories what remains of the collection. He prepares a card catalogue of 28,200 objects.

1909 Stanford University's new Medical School moves its departments of anatomy, physiology, and bacteriology into the extreme western block—known henceforth as the Museum "annex"—that was separated from the central building when the connecting wings collapsed in the quake.

1911 Thomas Welton Stanford makes

the University a substantial gift to restore the Museum.

1916 The historic railroad engine The Governor Stanford is installed in the North Rotunda.

1917 Pedro Lemos, acting director of the San Francisco Art Institute, is named curator of the Museum. A printmaker and art educator, Lemos serves also as editor of *School Arts Magazine,* published in Worcester, Massachusetts, and as Palo Alto architect.

The T. W. Stanford gift is used for the construction of the art gallery that bears his name. It becomes the focus for special loan shows, while the permanent collection remains in the Museum as a resource for students; the ruined building is periodically open to the public.

1922 On a university-sponsored trip to the Southwest, Lemos collects Pueblo pottery, adding historic works from Acoma, Laguna, Zia, and Zuñi to the American Indian objects acquired by Jane Stanford in the 1890s.

1924 Academic departments in the biological sciences—botany, entomology, and zoology—are moved into the Museum's south wing. Included are the Dudley Herbarium (now at the California Academy of Sciences) and the David Starr Jordan collection of fishes and invertebrates.

1940 With students in her Stanford classes, Hazel Hansen (A.B. 1920, A.M. 1921, Ph.D. 1926), professor of classics, begins the sorting and mending of vases and sculptures from the Cesnola collection damaged in the 1906 earthquake as an exercise in archeological methodology. The classics

Included in Mortimer C. Leventritt's substantial gift were two drawings by Giovanni Battista Tiepolo and three by his son Giovanni Domenico. This drawing is from an album by Giovanni Domenico depicting the many adventures of Pulchinello created for the entertainment of children.

department continues this practice to the present day.

Mortimer C. Leventritt (A.B. 1899), makes a sizable gift to Stanford. His collections of Venetian and Asian art are installed in the Art Gallery.

1945 Pedro Lemos resigns, and the Museum is closed to the public. After forty years of neglect, valiant efforts to organize and conserve the collection are initiated by Helen Green Cross and John LaPlante, a graduate student.

1953 Interested members of the community—the nucleus of the Committee for Art—begin to raise money to refurbish the Museum. Paintings, prints, watercolors, and a sculpture by Paul Manship are bequeathed to the Museum by Douglas H. Campbell.

1954 The Museum reopens with the chair of the art department, Dr. Ray Faulkner, as director; Helen Cross, assistant director; and three faculty members as curators: John LaPlante,

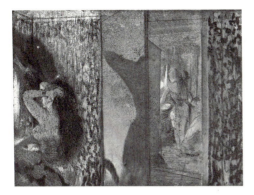

Degas's etching Actresses in Their Dress-ing Rooms *is from a group of nineteenth-century prints given by Marion E. Fitzhugh and Dr. William M. Fitzhugh in memory of their mother, Mary E. Fitzhugh. Also repre-sented in their 1963 gift were works by Manet, Meryon, Whistler, and Hopper.*

Asian art; Hazel Hansen, classical antiquities; and Bert Gerow, an-thropology.

The Last Spike is returned to the Museum after being stored for the University by Wells Fargo Bank for 27 years. At a celebratory event in the Museum, the Spike is placed in its specially designed safe.

The Board of Governors of the Committee for Art holds its first meeting.

Mr. and Mrs. Stewart M. Marshall present the first items of what is to be-come a major gift of art objects to the Museum. By 1970 the Marshall col-lection comprises 250 works of art, among them Renaissance and baroque paintings, early Chinese bronzes, and later celadons and porcelains.

1955 Florence Williams (A.B. 1911) bequeaths to the Museum approx-imately 200 paintings and drawings by the Los Angeles modernist Rex Slinkard.

1957 The first of a series of Hidden Treasure auctions is held to raise money for art acquisitions.

1958 John LaPlante is named associ-ate director; in 1962, he becomes the Museum's acting director. Under his aegis many exhibitions of Asian art are mounted in the T. W. Stanford Art Gallery.

1960 Hattie Hecht Sloss makes a gift of prints and drawings on the theme of mother and child.

1961 The Museum's newly re-modeled space for special exhibitions is dedicated in honor of Sarah Love Meidel.

1962 Mrs. Philip Lilienthal (Marjorie G. Huguet, A.M. 1955) makes the first of many gifts of art objects, pre-dominantly Asian, to the Museum in memory of her husband.

1963 May: The locomotive The Gov-ernor Stanford is moved to the Califor-nia Railroad Museum, Sacramento.

September: Lorenz Eitner is ap-pointed chair of the art department. Albert Elsen, the Rodin scholar, is vis-iting professor for the year, returning in 1968 as a member of the Stanford faculty. A graduate program in the history of art is established, and with its introduction the Museum takes on added importance as a laboratory for the study of original works of art.

1964 Partial modernization of the Museum building is undertaken: light-ing, ventilation, fresh paint, and new carpeting for the two main galleries on the first and second floors. Newly in-stalled galleries of European and Asian art are opened, and a regular program of changing exhibitions is established for both the Museum and the Art Gallery.

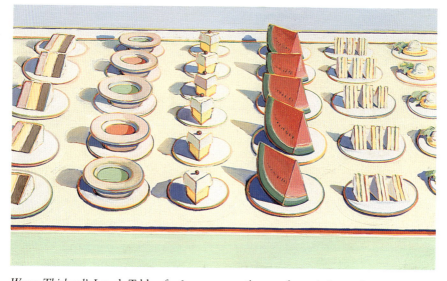

Wayne Thiebaud's Lunch Table *of 1964 was among the very first paintings to be acquired for the Museum with funds provided by the Committee for Art.*

A group of European prints is given to the Museum in memory of Mary E. Fitzhugh by her son William M. Fitzhugh, Jr. (A.B. 1930), and daughter Marion E. Fitzhugh.

Classics professor T. B. L. Webster catalogues and begins to publish the Museum's collection of antiquities.

1966 Patricia Rose, lecturer in Renaissance art, begins to catalogue the Robert M. Loeser collection of old master prints given to the Museum in 1923, 1928, and 1944.

1968 Françoise Forster-Hahn is appointed curator of the Museum. Isabelle Raubitschek and Suzanne Lewis, faculty members in the art department, serve as curators of museum collections and exhibitions for classical antiquities.

The Buck jade collection, the gift of Alice Meyer (A.B. 1905) Buck in memory of her husband, Frank, is installed in a specially designed gallery.

The Stewart M. Marshall Endowment Fund for the renovation and maintenance of museum galleries is established.

1969 In conjunction with the Department of Art, the Educational Services Program of the Committee for Art is established for the training of museum docents. Tours of the Museum and Art Gallery are later augmented by tours of the Rodin Garden, campus sculpture, and the Frank Lloyd Wright house at Stanford. Lectures in the public schools and in the community are offered, and in later years summer art-enrichment programs for children in the lower grades are added.

1970 New appointments to the museum staff are Betsy G. Fryberger, curator of prints and drawings, and Anita Ventura Mozley, registrar, and later curator of photography.

1971 *The Stanford Museum*, a scholarly journal edited by Fryberger and

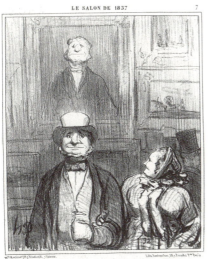

LE SALON DE 1857 7

.C'est tout d'méme flatteur d'avoir son portrait à l'exposition.

Daumier's lithograph, from a set satirizing the Salon of 1857, is one of several hundred caricatures assembled by Lorenz Eitner. Included are prints and drawings by Rowlandson and Gillray, Grandville and Gavarni, as well as works by less familiar but no less witty pens.

Mozley, is inaugurated.

1972 The newly installed American Gallery is opened with the exhibition *Eadweard Muybridge: The Stanford Years*, organized by Mozley.

1973 With special grant funds Carol Hay is appointed as education curator for three years.

1974 B. Gerald Cantor makes a major gift of 87 Rodin sculptures to the Stanford Museum and loans 50 sculptures as promised gifts. By 1981 an additional 19 sculptures have come to Stanford together with related drawings and photographs.

The Contemporary Art Gallery is opened on the Museum's upper floor.

The Robert E. and Mary B. P. Gross Acquisition Fund is established by Mr. and Mrs. Charles Ducommun

in honor of Mrs. Ducommun's parents; the print and drawing study room is named in their honor.

1975 The Arthur W. Hooper (A.B. 1905) collection of prints and drawings is given in memory of their father by Margaret Hooper Jameson and John A. Hooper.

1978 Carol M. Osborne is named assistant director and curator of collections, replacing Sven Bruntjen, assistant director for the preceding three years. Patrick J. Maveety is appointed curator of Asian art.

1980 The Museum receives a general operating grant from the Institute for Museum Services for conservation.

Alice Meyer Buck bequeaths a substantial sum to the Museum for acquisitions together with a small group of nineteenth-century French and American paintings formed by her father, Henry Meyer.

When the botany department vacates the south rotunda after 57 years, the Museum is given over entirely to the display of works of art. Possible now are the installation of the B. Gerald Cantor collection of Rodin sculptures on both upper and lower floors of the rotunda and the display of Native American objects and early-twentieth-century works. The African, Oceanic, and Pre-Columbian galleries are inaugurated under the direction of Victor Zurcher.

James and Mary Alinder make their initial gifts of photographs that by 1990 number 250.

1982 An elevator is installed to make the Museum accessible to handicapped visitors.

1984 The Museum receives the bequest of twentieth-century graphics

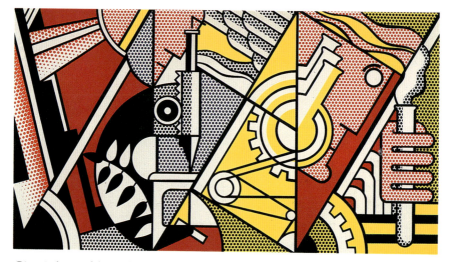

Given in honor of the 100th anniversary of the founding of Stanford University by Drs. K. and J. Marmor's Cardea Foundation, this lithograph/screenprint by Roy Lichtenstein celebrates Peace through Chemistry.

from Dr. Harold C. Torbert (A.B. 1929, M.D. 1933) and his wife, Frances Burger (A.B. 1929) Torbert.

Mr. and Mrs. Dale H. Budlong establish the Vincent Bressi Acquisition Fund in honor of Mrs. Budlong's parents.

1985 The B. Gerald Cantor Rodin Sculpture Garden is dedicated.

Charles Ducommun establishes the Palmer Gross Ducommun Acquisition Fund in honor of his wife.

1989 Lorenz Eitner retires after 26 years at Stanford. Wanda Corn is the new chair of the art department and is appointed acting director of the Museum while a search is under way for a permanent director.

The Cowles Charitable Trust estab-lishes a fund for exhibitions in contemporary art. The Kazak Fund for Acquisitions and Exhibitions is established by an anonymous donor.

October 17: The Loma Prieta earthquake causes extensive structural damage to the Museum, and the building is closed to the public for repair of seismic damage. The exhibition program continues in the Art Gallery.

The Museum Earthquake Renovation Fund is established.

1990 William Turnbull Associates of San Francisco prepare a feasibility study for the renovation and modernization of the Museum.

1991 Thomas K. Seligman is appointed Museum director.

ASIAN ART

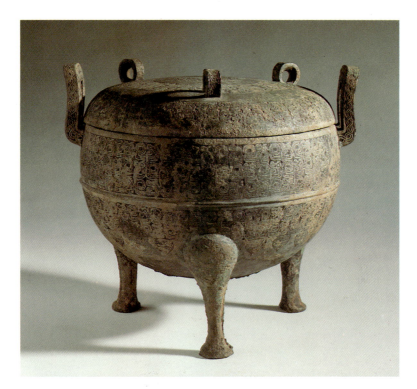

Ritual Food Vessel (*ding*), ca. 500 B.C.
China, Eastern Zhou dynasty (771–256 B.C.)
Bronze with black lacquer, 9¼ in. high (23.5 cm)
Gift of Mr. and Mrs. Stewart M. Marshall 1964.118

In ancient China, bronze vessels were made for the ruling elite to use in elaborate rituals of ancestor worship. Cast of an alloy of tin and copper in clay section molds around a clay core, the vessels were made in a variety of shapes for cooking meats or cereals.

By the end of the sixth century B.C., the date of this piece, decoration on ritual bronze vessels had become less extravagant and comparatively austere, with simple forms embellished with circular bands of flat relief. A design of intertwined, stylized serpents has been emphasized with an inlay of black lacquer. The loop handles are incised with twisted rope designs. The three ring handles on the lid, as well as the area below the lowest band on the body, are decorated with a row of pendant blades. This style of decoration, the most distinctive of the late Zhou period, is known as Liyu, after the village in northern Shanxi where the vessels were first discovered.

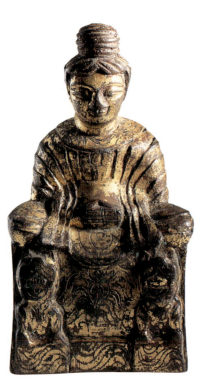

Seated Buddha, 4th–5th century
China, Six Dynasties (A.D. 220–589)
Gilt bronze, 3⅜ in. high (8.5 cm)
Gift of Mortimer C. Leventritt (A.B. 1899) 1941.39

The monumental character of this sculpture belies its small size. The Shākyamuni Buddha, seated in the lotus position on a lion throne with his hands in a gesture of meditative concentration, was one of the most popular images of the Buddha during the early Six Dynasties period. The style of the monk's robe, which indicates his renunciation of worldly pursuits, and the fact that it is worn over the shoulders testify to Gandharan influence on the work. Ancient Gandhara, in present-day Pakistan, was the home of a hybrid style of art that synthesized Indian, Persian, and Greco-Roman elements; it flourished in the early centuries of the Christian era. Images such as the *Seated Buddha* were transmitted to China through Central Asia. A loss of faith in traditional Chinese hierarchies sparked an enthusiasm for the foreign Buddhist doctrine that arrived there before the end of the Han dynasty.

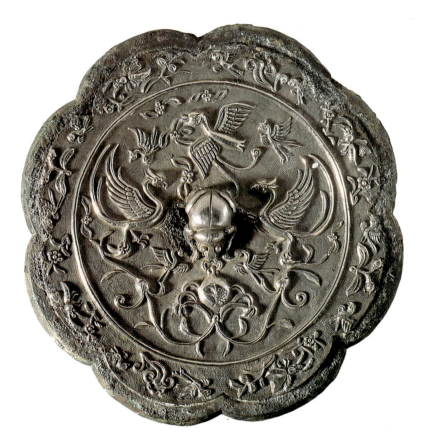

Eight-lobed Mirror, late 8th century
China, Tang dynasty (A.D. 618–906)
Bronze with inset silver sheet, 5⅜ in. diam. (13.7 cm)
Gift of Frank G. Marcus 1954.259

In ancient China, mirrors were credited with magical powers, including an ability to ward off evil influences and to forecast the future. Brides carried them to their new homes to avoid harm or bad luck.

Tang mirrors vary greatly in shape, those with lobes or foliations being very common, and at this time the stylized images of previous periods gave way to naturalistic representations of animals, birds, and flowers. The Stanford mirror has been inset with a silver sheet decorated in the center with a knob in the form of a crouching frog flanked by a pair of phoenixes. These birds symbolize good wishes and suggest that the mirror may have been a wedding gift. A stylized flower with buds and tendrils conveys a wish for many children. The outer band is decorated with birds, flowers, clouds, and insects and probably conveys a wish for the continued harmony of the universe and the balance of the forces of nature.

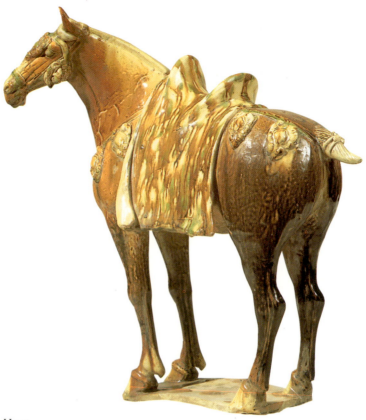

Horse
China, Tang dynasty (A.D. 618–906)
Earthenware with chestnut and three-color
(*sancai*) glazes, 23 in. high (58.3 cm)
Gift of Richard Gump (A.B. 1928) in memory of
Lloyd Dinkelspiel, Sr. 1980.176

Earthenware tomb figures were popular in China from at least as
early as the Han dynasty (202 B.C.–A.D. 220) and continued in im-
portance through the Ming (1368–1644). From no period in Chinese
history, however, are they as well known and admired as from the
Tang, when their vigor and naturalness are their outstanding features.
The Stanford horse, with his head turned slightly to the left, is par-
ticularly well molded, and the detailed pendant decorations on his
elaborate bridle and trappings reflect the influence of western Asia
and the Greco-Roman world beyond. The horse is similar to those
found in imperial family tombs that are dated to the early years of
the eighth century. The variety of figures found in Tang tombs—
animals, fantastic guardian figures, and humans, including officials,
servants, musicians, polo players, dancing girls, and caricatured
foreigners—gives a vivid picture of contemporary life.

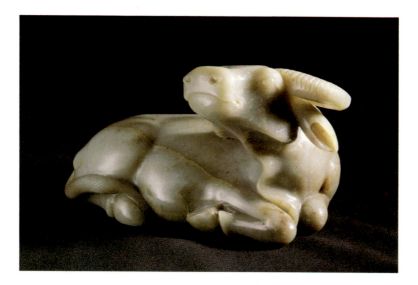

Reclining Water Buffalo
China, Ming dynasty (1368–1644)
Grayish green nephrite, 11½ in. long (29.2 cm)
Gift of Alice Meyer (A.B. 1905) Buck
in memory of her husband, Frank Buck 1968.38

For the Chinese, the word "jade" evokes five colors: red, green, yellow, black, and white, with white being the color preferred by the Chinese throughout their history. The various hues are caused by small quantities of metallic particles such as iron, manganese, and chromium in the stone. Iron, the most common impurity, results in colors ranging from pale green to a warm brown.

This buffalo is one of the most popular pieces in the Buck collection, given to the Museum in 1968. The animal raises its head in a gesture that suggests it is listening to a distant sound. The carving is carefully done—the underside with its folded legs and hooves is as complete as the visible upper part. The water buffalo was especially important to agricultural peoples throughout Asia in its various guises as draft animal, sacrificial offering, and symbol of the earth.

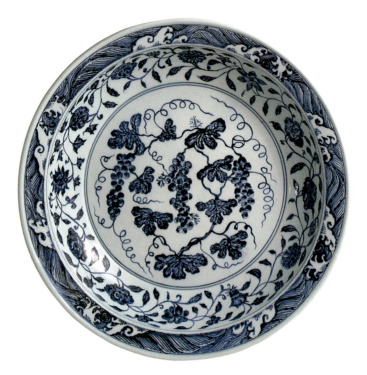

Large Dish
China, Ming dynasty, Yongle period (1403–24)
Porcelain with underglaze blue decoration,
14¾ in. diam. (37.5 cm)
Gift of Mrs. Charles Ure (A.B. 1908) 1974.136

Among the Museum's most important examples of Chinese ce-
ramics, this large dish has an air of refinement and a sense of spa-
ciousness in its decorative scheme that mark it as a product of the
early fifteenth century. The potting is extremely carefully done, and
the body is finer and whiter than the wares of the fourteenth century.
The occasional spots in the cobalt oxide pigment and the unglazed
base are characteristics of early-fifteenth-century wares. This dish
was probably made at or near Jingdezhen, the Chinese porcelain capi-
tal in eastern Jiangxi province. Porcelains there were intended for do-
mestic use among the upper classes and the court as well as for export
to Southeast Asia and the Near East.

The Stanford dish, with its central motif of three bunches of
grapes, represents one of the best-known designs incorporating fruit.
The rim is decorated with a design of breaking waves, and the ca-
vetto (the inner wall of the dish) with a wreath of twelve different
kinds of flowers, which is repeated on the outside.

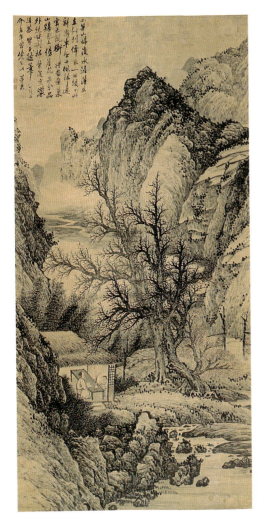

Wang Gai (China, active ca. 1677–1705)
Landscape in the Manner of Juran
Hanging scroll
Ink and slight colors on paper,
78 × 38³⁄₁₆ in. (197 × 97 cm)
Committee for Art Fund 1967.66

Wang Gai is best known as the supervising author of the famous *Mustard Seed Garden Manual of Painting*, first published in 1679, whose woodblock illustrations were an influential source for the transmission of systematized modes of painting to China and Japan. Wang was the only recorded pupil of the major painter Gong Xian (ca. 1619–1689).

The present painting represents two aspects of Wang's style. The rounded boulders and profuse foliage dots in the mountain peaks are a codified reflection of the manner of the tenth-century monk-painter Juran, whose name is cited in the artist's inscription at the upper left. The thick, squarish contours of the rocks and trees, the heavy textures, and the powerfully somber tone of the landscape reveal a more immediate source in the style of his teacher, Gong Xian. The prominent silhouettes of the two broad, bare-branched trees in the center of the composition are part of Wang's own manner, and the recession of the deep valley beyond recalls the appearance of European spatial formulae elsewhere in his art.

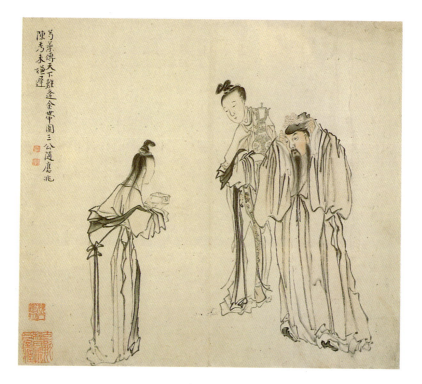

Huang Shen (China, 1687–1772)
The Statesman Han Qi Adorning Himself with Peony Flowers
Leaf from an album of figure paintings
Ink and colors on paper, 11⅜ × 12¹⁵⁄₁₆ in. (290 × 329 mm)
Committee for Art Fund 1967.60

This painting depicts a story from the life of the illustrious Song official Han Qi (1008–1075). When Han was serving at Yangzhou, a rare variety of peony known as *jindaiwei* unexpectedly came into bloom. Han is shown taking advantage of the event to adorn his headgear, while two female companions attend him. This leaf is part of an album illustrating events from the lives of famous poets, philosophers, and literary characters. The episode reflects a moment of renown from the early history of Yangzhou and may have been designed to appeal to the audience Huang Shen found when he moved there from his native Fujian province in 1724. The active poses of the figures and the dynamic, wavering drapery lines seen here foreshadow the calligraphic flourish of his developed manner, which eventually brought him success in the Yangzhou art world.

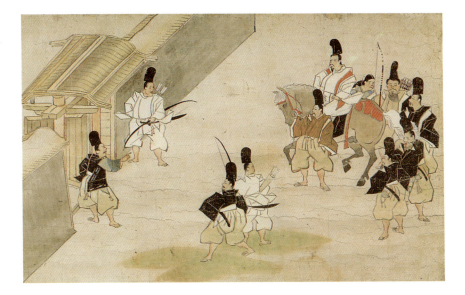

Illustrated Biography of Saint Hōnen (Hōnen Shōnin Eden)
Japan, Kamakura period (1185–1333)
Section of a handscroll
Ink and colors on paper, 12½ × 20¼ in. (319 × 514 mm)
Gift of Mrs. Philip N. Lilienthal (Marjorie G. Huguet,
A.M. 1955) in memory of her husband 1964.6

This fragment, cut from a horizontal handscroll, shows an episode
from the life of the priest Hōnen (1133–1212), the founder of the Pure
Land sect of Buddhism. Sets of narrative handscrolls were commis-
sioned by aristocrats or clergy typically to celebrate the lives and mi-
raculous deeds of famous monks, to illustrate works of fiction, to
expound religious doctrine, or to chronicle histories of shrines and
temples. These scrolls were executed in a style called Yamato-e, which,
as seen here, is characterized by calligraphic ink outlines filled in with
colorful vegetable and mineral pigments, lively faces and animated ges-
tures, and a steeply slanted ground-plane.

Demand for illustrations of the life of Hōnen increased steadily
throughout the late thirteenth and into the fourteenth century. Versions
of the *Illustrated Biography of Saint Hōnen* are so numerous that it is
impossible to identify this segment exactly. It appears to illustrate the
episode from the priest's turbulent life in which he is about to be ar-
rested by the imperial guards and sent into exile.

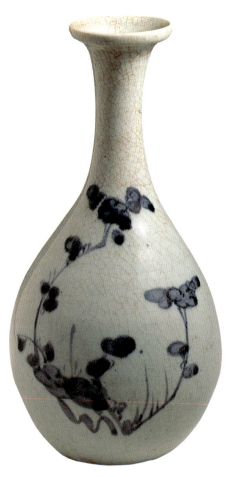

Bottle, 1615–50
Japan, Edo period (1615–1867)
Porcelain with underglaze blue decoration,
8⅞ in. high (22.5 cm)
Museum Purchase Fund 1965.64

The Japanese did not produce porcelain until the beginning of the seventeenth century and only then, according to one popular story, because porcelain clay was discovered by a Korean potter captured by the Japanese during the so-called Pottery Wars of the 1590s.

These wares, sometimes called early Hizen from the name of the province where they were made, were decorated rather summarily with flowers and grasses in a style that reflects their Korean origins. This loose Korean style soon gave way to Japanese tastes.

The Dutch promoted the export trade of Japanese porcelains because Chinese production was interrupted by the downfall of the Ming dynasty. By the eighteenth century Japanese porcelain had become popular in Europe and inspired much European porcelain.

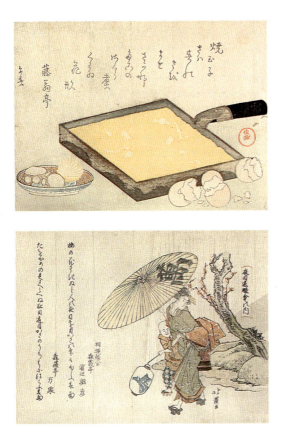

Shōsadō Shunman (Japan, 1757–1820)
Porcelain Dish, Omelet Pan, and Egg Shells, 1810

Totoya Hokkei (Japan, 1780–1850)
Woman under an Umbrella in the Rain, 1810
Woodblock prints, each 5½ × 7 ½ in., sheet (139 × 190 mm)
Gift of Maggie P. Van Reed Biddle 1962.86

Among several Japanese objects given to the Museum in 1892 by Maggie P. Van Reed Biddle was one she listed as a "package of odd pictures," acquired by her brother Eugene in Japan. The Van Reed album comprises 187 small color woodblock prints by many different artists. Called *surimono*, these prints with witty poems (*kyōka*) were exchanged by friends on New Year's and other special occasions.

Of the more than forty artists represented in the album, titled *Year's End Market* (*Toshi no Ichi*), Hokusai and his talented pupil Hokkei have each designed eight prints. Hokkei's *Woman under an Umbrella* is complemented by two poems by Shinratei Manzō. Shunman was well known for his paintings of beautiful women as well as *surimono* still lifes, book illustrations, and poetry. His print includes a poem by Tōōtei.

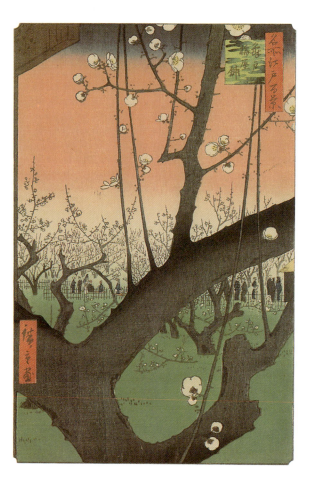

Andō Hiroshige (Japan, 1797–1858)
Plum Garden at Kameidō, 1857
Woodblock print, 13¾ × 9⅜ in., sheet
(350 × 240 mm)
Committee for Art Fund 1984.473

Hiroshige is arguably the best-known Japanese woodblock artist in the West. His favorite subject was the scenery of his native land, especially the city of Edo (Tokyo), which he depicted in his last work, *One Hundred Views of Famous Places in Edo*. The series, which the artist considered to be his masterpiece, consists of 119 prints, of which *Plum Garden at Kameidō* is number 30. One of Hiroshige's finest compositions, it shows people through the branches of a blossoming plum tree with a deep blue sky at the top, turning to red and white below. In 1888, *Plum Garden* was one of two prints from the series to be copied in oils by Vincent van Gogh.

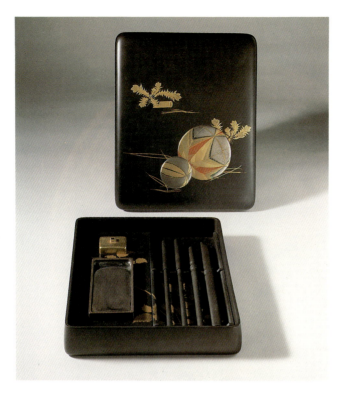

Shibata Zeshin (Japan, 1807–1891)
Box for Inkstone (suzuribako) and Stationery Box (ryoshibako)
Lacquer on wood, inlaid with mother-of-pearl and silver squares,
8½ × 10 × 1¾ in. (21 × 25.4 × 4.4 cm)
Gift of Jane Stanford from the Ikeda Collection 9103

The decorative scheme of this set of boxes refers to the four seasons. The ball decorated with countless intersecting threads (*temari*), shown on the lid of the *suzuribako*, is a symbol of the winter festival; on the interior are a sword handle, arrows, and a beetle on a flowering plant, suggesting spring and Boys' Festival Day. The *suzuribako* has two brushes, a knife, and a pointed instrument. The lid of the *ryoshibako* has gift-wrapping papers (*noshi*) folded over leaves with a writing brush and cords associated with New Year's celebrations. Inside are a Buddhist gong and mallet with mandarin oranges, objects associated with autumn. The interior is decorated with a sake gourd and cherry blossoms, suggesting a bibulous spring outing. Among the flowering vines and fruits decorating the exterior are a morning glory (with a poem), cherry blossoms, and persimmons, plus silkworm moths and cocoons. These boxes are given to Shibata Zeshin, considered the greatest lacquer artist of the nineteenth century. Zeshin was also an accomplished painter known for his simple yet sophisticated compositions.

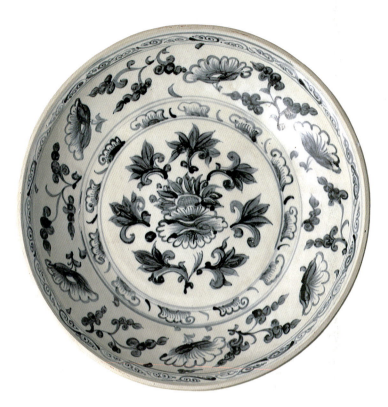

Dish
Vietnam, Le dynasty (1428–1528)
Porcelain with underglaze blue decoration,
14¾ in. diam. (37.5 cm)
Committee for Art Fund 1987.17

The blue decoration of Vietnamese ceramics is often grayish, although some of the best pieces are painted in a linear manner with a bright blue pigment, which was probably imported. Vietnamese ceramic shapes are highly varied and include not only large plates and bowls but ornamental wares and many miniature items. The bases of many pieces are covered with a characteristic chocolate-colored slip.

The Chinese occupation of northern Vietnam from 1407 to 1428 inspired a new generation of Vietnamese underglaze blue wares. Chinese-style decoration is seen on many shapes that are not themselves copies of Chinese wares. This dish is decorated in the center with a combination of chrysanthemum and peony flowers surrounded by a band of stylized breaking waves; the cavetto has a floral pattern below a narrow band of classic scrolls inside the unglazed, upturned rim.

Vase (*maebyong*), late 18th–early 19th century
Korea, Choson dynasty
Porcelain with underglaze blue decoration,
15⅜ in. high (39 cm)
Gift of Dr. and Mrs. William C. Kerr 1963.20

The earliest Korean blue-and-white wares were probably produced in the fifteenth century, but owing to the scarcity and high cost of cobalt a distinctly Korean style of restrained decoration soon developed, which subtly transformed the contemporary Chinese prototype. For the next hundred years the limited numbers of blue-and-white wares produced were reserved for use by the aristocracy.

The Korean style of sparse decoration and rapid brushwork is reflected in Japanese porcelain of the first half of the seventeenth century. It was not until the eighteenth century that cobalt became more available, and even by mid-century its cost prohibited production of any blue-and-white but ceremonial dragon jars. By late in the century the official kilns were producing nearly fourteen thousand units annually, of which two-thirds were blue-and-white. Korean porcelain is characterized by its dignified and restrained decoration, as seen in this example.

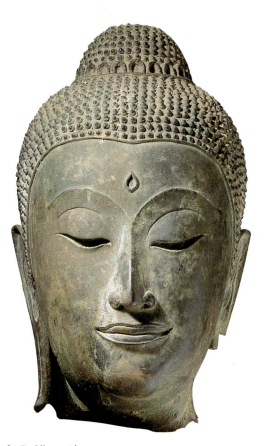

Head of a Buddha, 16th century
Thailand, Ayutthaya period
Bronze, 12 in. high (30.5 cm)
Gift of Mortimer C. Leventritt (A.B. 1899) 1941.226

The stylized features of this head express the supreme spirituality of
the Buddha image during the Ayutthaya period: half-closed eyes
with bulging lids, a delicate arcading of the eyebrows that join at the
bridge of the nose, and the rather low *ushnīsha*, the protuberance on
the skull that indicates the supernatural wisdom of the Buddha, now
missing its flame finial. Between the eyes is the *ūrnā*, a divine eye, a
sign of spiritual insight. The Stanford head shows the Buddha's hair
arranged in short clockwise-turning curls, another one of the thirty-
two distinguishing marks of a Buddha. While the Mahāyāna form of
Buddhism practiced in North and East Asia developed multiple di-
vinities, that of Southeast Asia paid homage to Buddha through de-
pictions of scenes from his life, his previous lives, or through single
images, such as this head.

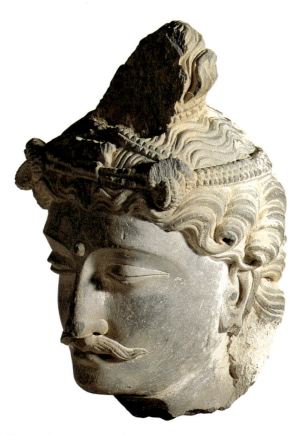

Head of a Bodhisattva, 2nd–3rd century
Gandhara
Schist, 10⅛ in. high (25.7 cm)
Gift of Mrs. Philip N. Lilienthal
(Marjorie G. Huguet, A.M. 1955) 1970.114

Art from Gandhara, or present-day northwestern Pakistan, illustrates the mix of cultures that took place in that commercial crossroads two thousand years ago. This exquisite head, finely carved from a friable crystalline stone, shows the blending of Hellenistic facial types and Buddhist religious imagery. The *ūrnā* and the high chignon identify the head as a bodhisattva. Not generally characteristic of bodhisattvas, however, is the clasp holding the strands of beads shaped like the emblem of the Three Jewels of Buddhism. Because this attribute is not firmly fixed to any one being, this head could represent one or more of several bodhisattvas associated with jewels or jewel-like qualities. The head thus dates to a period of codification in Buddhist imagery, during which distinct identities were formed from the large numbers of bodhisattvas mentioned in early Buddhist writings.

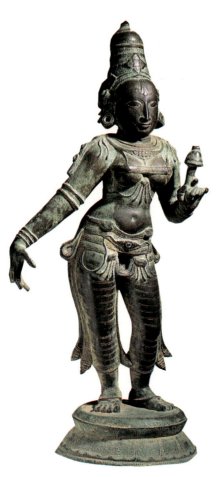

Sītā, 17th century
South India, probably Tanjore district
Bronze, 21½ in. high (54.5 cm)
Gift of Alice Meyer (A.B. 1905) Buck 1956.19

This sculpture represents Sītā, the wife of Rāma, one of the avatars of the god Vishnu and hero of the *Rāmāyana*, the Tamil epic poem of South India. The *kucabandha* (breast band) she wears is an attribute of the great goddess Shridevi and expresses Sītā's complete identification with the deity, just as Rāma is himself a temporal and spatial expression of Vishnu as the supreme god existing beyond time, place, and form. In her left hand Sītā holds a wilting lotus, symbol of accomplished fecundity.

The figure's suggestively swollen limbs and body are informed by the Indian convention of breath control, which represents bodies as though inflated by the indrawn breath. The figure appears to be hollow and very thinly cast. In actuality it is solid; constraints of curses "to the seventh generation" made certain that such South Indian bronze figures were cast with the full weight of metal.

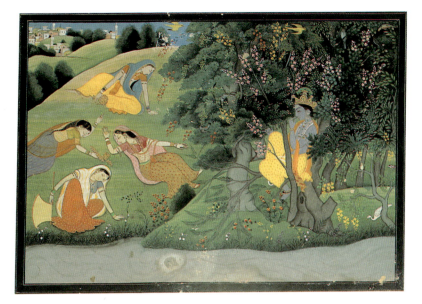

Krishna Fluting to the Milkmaids, ca. 1780
India, Kangra
Tempera on paper, 6½ × 9½ in. (166 × 243 mm)
Alice Meyer (A.B. 1905) Buck Fund 1982.144

The legend of Krishna was the favorite theme of the school of miniaturist painters that flourished at Kangra in the Punjab hills under the Raja Sansar Chand at the close of the eighteenth century. Krishna, one of the most widely worshiped of the Hindu deities, was reputed to have been brought up as a cowherd and is often depicted playing a flute. Scenes of his dalliance with Rādhā by the banks of the river are frequent. The Stanford episode is taken from the *Gīta Govinda* of Jayadeva, an ecstatic celebration of the couple's union, and one that provided artists with an opportunity to depict the god in a luxuriant earthly setting. The fastidious drawing style, the flattened perspective, and the irrational scale of the colorful painting accentuate the dreamlike quality of the scene.

By the middle of the nineteenth century, the Sikh conquest and the advent of British rule put an end to the fine lyrical painting being done at Kangra, the last of the hill schools.

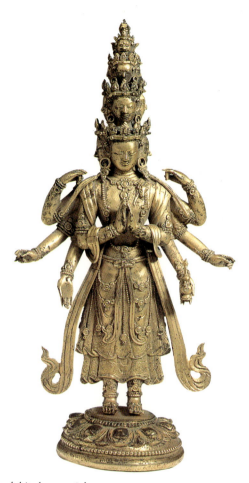

Eleven-headed Avalokiteshvara, 18th century
Tibet
Gilt bronze, 6⅝ in. high (16.8 cm)
Gift of Jane Stanford from the Ikeda Collection 9184

Avalokiteshvara is the most popular bodhisattva in Buddhism; his name is translated as "the sublime divinity of penetrating and charming vision." The version illustrated here symbolizes the Buddha's compassion; his eleven heads allow him to look in all directions so he can assist all creatures in resurrection. The heads of the three lower tiers wear a serene expression, while the face above them shows a fierce one; above them is the tranquil head of the bodhisattva's spiritual lord, the Buddha Amitābha. The dress and long flowing scarf are rendered in the Chinese style. During the eighteenth century there was a great interest in Tibetan Buddhism in metropolitan China. Avalokiteshvara's multiple hands convey his ability to aid those who need his powers while displaying the gestures of charity and adoration. Possibly missing from the other hands are the bow and arrow, the jewel, and the rosary and lotus that are usually held by such figures.

ART OF AFRICA AND THE AMERICAS

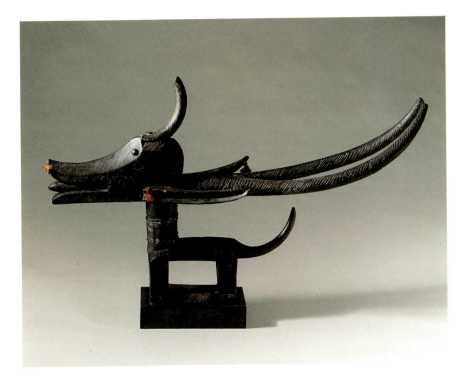

Chi-wara Headdress, 20th century
Mali, Bamana
Wood, metal, and fiber, 24¾ in. long (63 cm)
Anonymous gift 1969.53

The ritual life of the Bamana people centers on agriculture, and the name *chi-wara* refers to the legendary creature that taught humans how to cultivate the earth. These dance crests are worn by pairs of male dancers in vigorous planting and harvesting festivals. Each dancer is obscured by fibers cascading from the basketry cap to which the crest is attached. Rather than standing erect, the dancers, who are the most diligent and productive farmers, lean forward on canes so as not to offend the spirits.

The form of the mask varies from region to region, but each version combines references to several animals, including the roan antelope. Although vertical examples are carved from a single piece of wood, horizontal versions such as this one are made from separate pieces for the head and body that are joined by a metal collar. The masks are carved by blacksmiths, who in the Bamana and other Mande-speaking cultures form a separate caste, both shunned and revered.

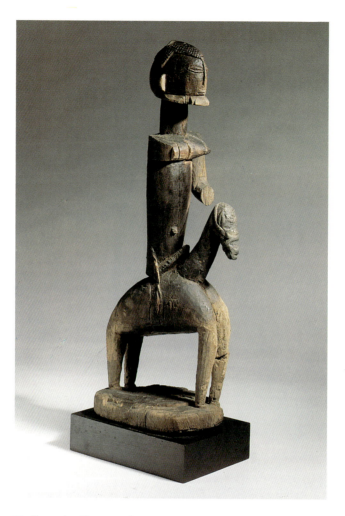

Equestrian Figure, 19th century
Northern Mali, Dogon
Wood, 22 in. high (55.9 cm)
Alice Meyer (A.B. 1905) Buck Fund 1982.100

Equestrian figures are among the oldest images to have been found in Mali, and they have at times been identified as representations of Lébé, the first *hogon*, or priest. In Dogon mythology, Lébé was also the first mortal who experienced death and brought it to mankind. In the Dogon genesis myth, the horse, too, has a key role, and for Lébé to be shown astride a horse would be appropriate to both his identity and his status.

In sub-Saharan Africa, where horses are rare, equestrian figures also function as symbols of royalty or conquest. The horse connotes wealth, power, speed, and high status and appears often in the myths and sculpture of the region.

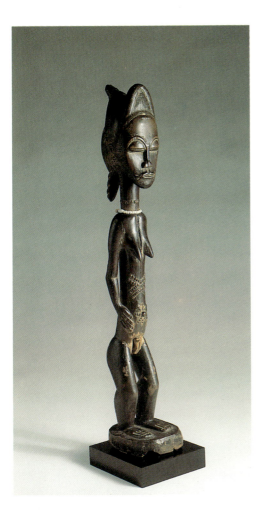

Standing Female Figure (blolo bla), 20th century
Côte d'Ivoire, Baule
Wood, metal, and beads, 17⅜ in. high (44.2 cm)
Committee for Art Fund and an anonymous donor 1986.186

The Baule believe that before people are born into this world they existed in a spirit world, where each had a mate, or "spirit spouse." Sometimes the spirit spouse becomes jealous of the living partner and disrupts aspects of that person's earthly life, particularly his or her marriage. When this occurs, the tormented person consults a diviner, who may recommend that a figure be carved to represent the disgruntled spirit.

The refinement of Baule carving is consistent with the need for an idealized figure, showing the spirit spouse in the prime of life, mature yet youthful. Its efficacy depends on its beauty. This particular figure is further enhanced by the presence of a small piece of precious metal in its forehead.

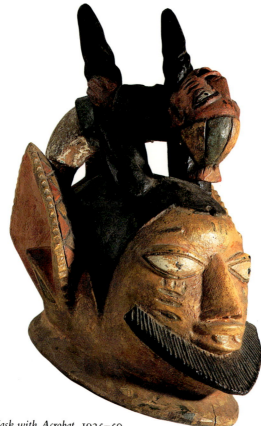

Egungun Mask with Acrobat, 1925–50
Southern Nigeria, Yoruba
Wood, 13 in. high (33 cm)
Gift of Janine and Michael A. Heymann 1981.203

The Yoruba ritual *odun egungun* honors the founders of each lineage. The commemorations usually occur in the spring but may also take place at a time of crisis, when the life-sustaining powers of the ancestors are needed. A wide variety of masks appears, worn with elaborate costumes consisting of layers of predominantly red vertical panels that fan out as the dancers spin. The combined effect of the masks, costumes, voices, and mannerisms of the masquerade emphasizes exaggeration and distortion, a reminder that the ancestors reside in another world.

This mask was probably carved by Oniyide Adugbologe (d. 1949) of Abeokuta or by one of his sons, members of a family noted for making *ibeji*, or twin figures, and *egungun* masks. The enlarged ears of this mask have several connotations. In a general sense they may allude to the wealth and lineage of the owner. At another level the ears and teeth suggest a hare, which the Yoruba consider to be a nocturnal animal. The hare refers to the world of witches, and perhaps to the hunter who destroys witches lest they snatch away children in the night.

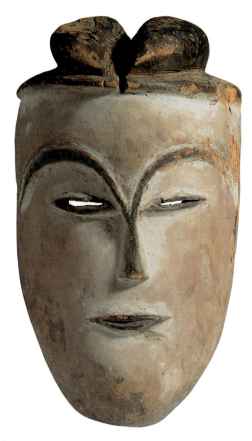

Face Mask, 20th century
Central Gabon, Sango
Wood, kaolin, and pigment, 13⅝ in. high (34.5 cm)
Anonymous gift 1986.189

The Sango, the Tsogho, and other groups in the Middle Ogowe region of Gabon regard masks of this type as especially powerful when seen at dawn or sunset. They are to be seen and used only by members of the Bwiti society, the association of males that regulates every aspect of village life. Bwiti is now found in various forms in other parts of Gabon, but it originated among the Tsogho. Bwiti ceremonies deal largely with initiation rites and funerals, and these masks appear after a time of mourning. They are a reminder that the deceased continue to take an interest in the affairs of the living and that the living must maintain contact with the ancestors.

White is the color of the dead, but the kaolin with which a mask or figure is whitened—called *pemba* in this area—also has protective and curative properties, a reference to otherworldly powers. White-faced masks are found throughout Gabon, often with an elemental depiction of facial features, such as this example.

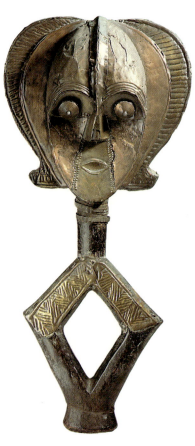

Reliquary Guardian Figure (mbulu ngulu), 20th century
Gabon, Kota
Wood, copper, and brass, 19¾ in. high (50.2 cm)
Gift of Miles L. Rubin (A.B. 1950, J.D. 1952) 1976.292

The Kota believe that their ancestors influence earthly matters. Because their goodwill is essential to each person's material and spiritual well-being, the forebears of the community must be propitiated. To this end, a basket or cylindrical bark box (*mbulu*) conserves the skull and bones of an important man or woman along with bits of shells, animal bones, and other objects of significance. A Kota lineage or clan commissions the creation of a guardian figure (*ngulu*) to watch over these remains. The reliquaries are stored together in a small shelter in or near the village.

These reliquary guardians are highly abstract, and this distinctive two-dimensional conception sometimes has a secondary face on the reverse side. Carved wood is plated with sheets of valuable metal, copper or brass or both. Copper is said to be a symbol of longevity and power, a tribute to the wisdom of the venerated ancestors. The diamond-shaped body is not fully covered with metal because the bottom is concealed in the box or basket.

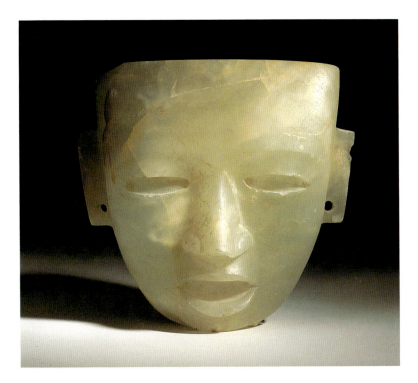

Mask, ca. A.D. 300
Mexico, Teotihuacán
Onyx, 5¾ in. high (14.6 cm)
Gift of Charlotte S. Mack 1960.91

The sacred metropolis of Teotihuacán, thirty miles north of present-day Mexico City, held over 200,000 inhabitants during the classic period of Mexican history. Two enormous pyramids, the Pyramid of the Moon and the Pyramid of the Sun, dominated the city, and its temples were decorated with frescoes honoring a large pantheon of gods in an elaborate iconography.

For funerary purposes masks such as this one were carved from beautiful hard stones like tecaline or onyx. The rather broad, trapezoidal shape of the mask with its delicate, rigid features and impassive countenance was probably embellished with a headdress or other ornamentation.

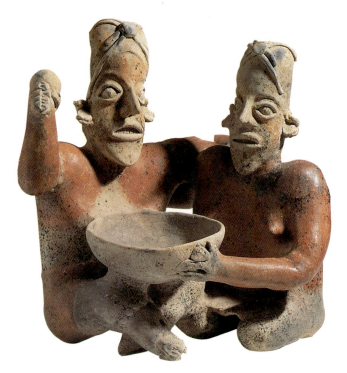

Seated Male and Female Couple, 200 B.C.–A.D. 500
Mexico, Jalisco
Terra-cotta, 14¾ in. high (37.5 cm)
Committee for Art Fund 1980.163

Ceramic figures from the shaft tombs of Jalisco in western Mexico often come in male and female pairs and very likely represent married couples. Seated together, arms linked, the figures of the Stanford piece share a common bowl; with right hand raised, the male holds a rattle, an object thought to attract guardian spirits. Note the exaggerated fingers and the economy with which the nails have been indicated simply by pressing a sharp instrument into the soft clay.

The distinctive features of the large, hollow terra-cotta figures—their elongated faces, prominent chins, tight-fitting caps, ridged eyes, and long, straight noses—identify them as classic Jalisco types in the style known as Ameca gray.

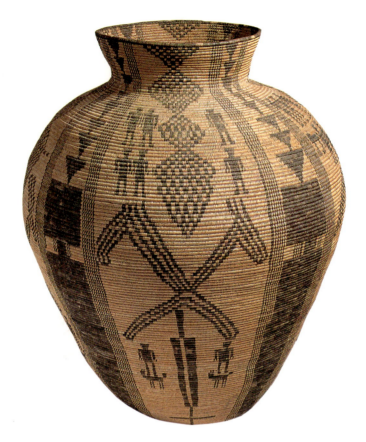

Basket, ca. 1890
Southwest United States, Western Apache
Three-rod bundled coiling of willow and
black devil's claw, 21 in. high (53.4 cm)
Gift of Jane Stanford 14669

Magnificent coiled baskets like this
one were the distinctive creation of the
women of the Western Apache, from
the forested mountains of central Ari-
zona. They wove the large baskets
from willow they had debarked,
scraped, and smoothed and from the
outer surface of the hornlike seedpod
of the black devil's claw (*Martynia pro-
boscidea parviflora*). Smooth, tough
martynia went protectively around the
rim of this urn-shaped basket, known
as an olla, and also formed the pat-
terns of men, women, dogs, and deer
that so appealed to Anglo buyers. In-
deed, complex designs like those on
this basket were a response to the taste
of tourists arriving on the railroad—
baskets of this shape and size were
made exclusively for them. For fine-
ness of texture and elegance of design,
the olla had few peers. Nonetheless,
the technique began to die out during
the 1930s and is only now being re-
vived by the great-grandchildren of
these nineteenth-century Indian
artists.

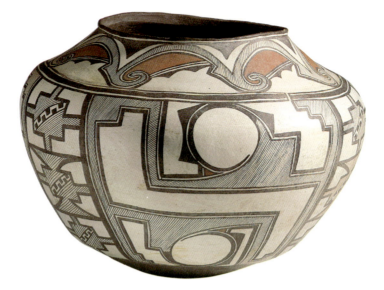

Large Water Jar, ca. 1870
Southwest United States, Zuñi
Polychrome terra-cotta, 11 in. high (28 cm)
Museum Purchase Fund 1962.74

Pottery designs from Zuñi Pueblo are formed by patterns of lines
rather than by surface color. Essentially black on white, the effect
produced is one of clarity and formality with the emphasis falling not
on symmetry but on rhythmic balance. Although design motifs are
associated loosely with the weather—rain and snow clouds, wind and
lightning—only one is consistently understood as a fixed symbol,
and that is the line dividing the neck from the body of the jar. As
Ruth Bunzel observed in her classic study of creative imagination in
pueblo life (1929), the line is equated with the life span of the potter;
when the road is joined, the life is ended. Hence the break in the line
encircling the neck of this handsome water jar.

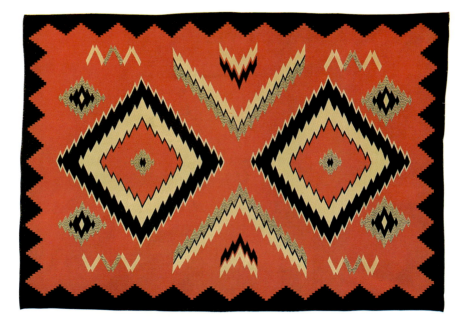

Blanket, ca. 1900
Southwest United States, Navajo
Germantown wool, 61¼ × 89½ in. (155.5 × 227.4 cm)
Gift of Mr. and Mrs. Edward Hamilton (A.B. 1928) 1965.99

The bright colors and lightning zigzags of this Navajo blanket denote weavings made from about 1880 to 1910. During this transitional period, commercially dyed yarns from Germantown, Pennsylvania, in virtually every color were being shipped a continent away by newly constructed rail routes to the Indian reservations of New Mexico and Arizona. There, traders in government-licensed trading posts distributed to native weavers not only the aniline-dyed wools but also patterns and motifs. In order to please Anglo buyers, who wanted rugs rather than blankets, traders encouraged a framed format with a border. For this purpose, they provided samples of oriental rugs, hiring artists to make designs that combined Navajo figures and Persian patterns with their own ideas. Although Germantowns were often of fine quality, they displaced the native tradition of using wools that had been sheared, carded, and handspun on the reservation.

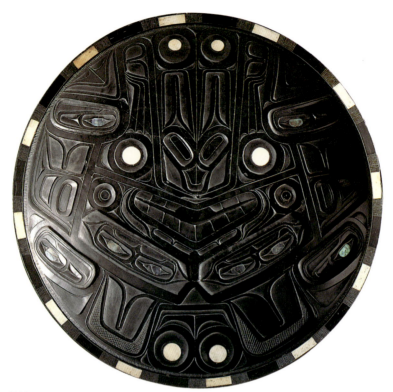

Dish, ca. 1890
Northwest Coast, British Columbia, Haida
Argillite inlaid with bone and abalone shell,
19⅟₁₆ in. diam. (48.2 cm)
Gift of Jane Stanford 7580

The figure of Gonaquadet, a wealth figure associated with high-ranking peoples of the Northwest Coast, has been worked into the circular design of this argillite dish acquired by Jane Stanford in the 1890s. Notable for its large size and mint condition, the deeply incised piece has been attributed to Tom Price (1860–1927), a Haida carving master from the town of Skidegate in the Queen Charlotte Islands. Argillite carving is unique to the Haida because they have sole custody of the carbonaceous shale found only in quarries near Skidegate. The

tradition continues to the present day.

Heavy and breakable, argillite has been of no practical use to the Haida, who eat from wooden plates or imported tableware, but it has been of great value in the tourist trade. Fur traders first began to buy it early in the nineteenth century. By the 1890s, collectors visiting the Northwest were taking a serious interest in argillite carving and recording the names of those who executed it. Among the collectors was Jane Stanford, who acquired eighteen other pieces in addition to this dish.

ANCIENT ART

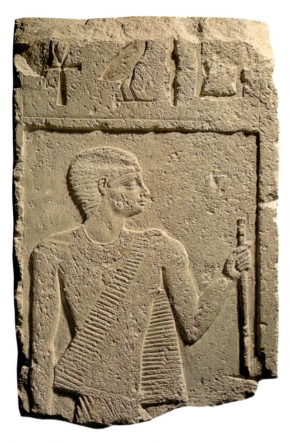

Relief Fragment from False Door, ca. 2480 B.C.
Egypt, Old Kingdom, Dynasty V (ca. 2480–2350 B.C.)
Limestone, 14 in. high (35.5 cm)
Gift of Jane Stanford 1966.544

More than four thousand years ago, this relief flanked the entry to the inner sanctum of an Old Kingdom tomb at Dashur on the west bank of the Nile south of Saqqara. The tomb was that of Wedjkaiankhi, an administrator of a frontier district. Ancient Egyptians believed that the spirit of the deceased entered a tomb's offering chamber through its "false door" to partake of food placed there by priests. A representation of the deceased seated before an offering table appears on the upper part of another fragment of this relief now held by the British Museum. The tomb was evidently excavated by the renowned French archeologist Gaston Maspero during the 1880s.

Jane Stanford acquired the limestone carving with another relief from the same door in 1904 on her second trip to Cairo. The two finely carved fragments form a part of the small but exemplary collection of Egyptian objects she presented to the Museum in memory of her son. Young Leland Stanford's enthusiasm for collecting Egyptica had been fostered by study of hieroglyphs at the Louvre.

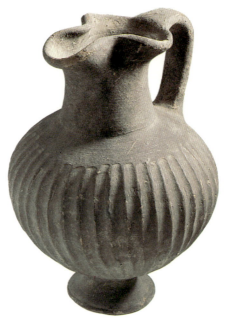

Jug, 1050–850 B.C.
Cyprus, Geometric period
Black slip, 6 in. high (15.2 cm)
Gift of Leland and Jane Stanford
from the Cesnola Collection 1125

Cypriot antiquities excavated during the 1870s by Luigi Cesnola, later the first director of the Metropolitan Museum of Art, formed the core of the archeological holdings of many American museums begun in the nineteenth century. All three Stanfords first became acquainted with Cesnola through their patronage of the Metropolitan, and when young Leland died, his parents purchased five thousand objects from Cesnola as the inaugural collection for their planned museum. Since the University's earliest days, the material has served as the mainstay of a colloquium in archeology. The vases, bottles, sculptures, figurines, coins, and amulets Cesnola excavated, albeit from ill-defined sites, represent cultural sequences from the Early Bronze Age through the Roman period. Because of Cyprus's location on the crossroads of the eastern Mediterranean, the island was the beneficiary of exchange throughout its history, taking foreign elements and modifying them to develop an unmistakable Cypriot style.

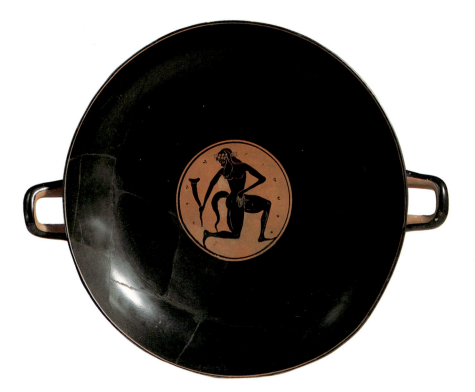

Bowdoin Eye Painter (Greece, Late Archaic)
Running Satyr with Drinking Horn, ca. 520 B.C.
Red and black terra-cotta, 15⅜ in. diam. with handles (39 cm)
Hazel D. Hansen (A.B. 1920, A.M. 1921, Ph.D. 1926) Fund 1970.10

The skill of Athenian painters and potters is exemplified at Stanford by several Greek vases purchased with funds bequeathed to the Museum by Hazel D. Hansen, professor of classics during the 1940s and 1950s. Selected for their pictorial elegance, technical skill, and graceful design, the vases provide historical, mythological, and religious imagery together with scenes of daily life in ancient Greece. The interior of this *kylix,* or drinking cup, has been decorated with a running satyr artfully fitted into a tondo. Working in a fine miniaturist tradition, the painter has applied the image in black against the red ground of the pottery with color added only for the wreath on the satyr's head. On the exterior, the image is worked in the reverse red-figure technique. Here, on each side between the handles, two large eyes, intended to ward off evil, flank a central figure. Because of the way the eyes are designed on this and a series of other drinking cups, among them a particularly fine example at Bowdoin College in Maine, the artist has been identified as the Bowdoin Eye Painter.

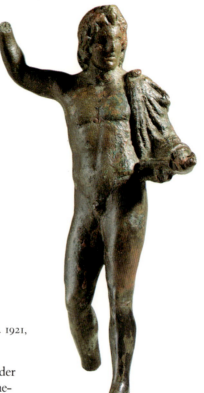

Alexander, ca. 330–100 B.C.
Greco-Roman, Hellenistic
Bronze, 4⅛ in. high (10.5 cm)
Hazel D. Hansen (A.B. 1920, A.M. 1921,
Ph.D. 1926) Fund 1975.47

The all-conquering genius Alexander
the Great is here portrayed in the he-
roic nudity of the classical world. The
youthful, beardless face with curly
hair swept above the brow identifies
the statuette as the legendary fourth-
century B.C. Greek ruler. Son of
Philip II of Macedonia, Alexander
claimed descent from both Herakles
and Achilles, the Homeric hero whose
attribute was the lance. Hence Alex-
ander is often portrayed with right
hand raised to hold such a spear, his
left hand carrying a sword, as here.
The naturalistic definition of the body
and the sense of turning in space that
the arrangement of arms and legs con-
veys are characteristics of late-fourth-
century sculpture. Indeed, the little
bronze is based generally on a now
lost but once famous marble sculpture
by Lyssipos, Alexander's court sculp-
tor. Differences in proportion, how-
ever, suggest a later date for the
Stanford bronze. The slender body
and small head introduced to the
canon by Lyssipos are here ignored—
the head is large and the anatomy
compact, modifications that suggest a
date in middle Hellenistic or Roman
imperial times.

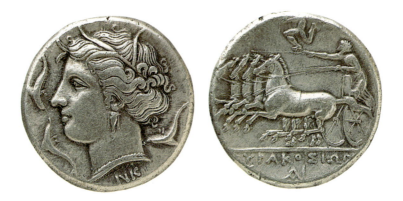

Arethusa (obverse) *and Quadriga* (reverse), 317–10 B.C.
Greece, Syracuse, Hellenistic
Four-drachma silver coin, 1⅛ in. diam. (2.4 cm)
Hazel D. Hansen (A.B. 1920, A.M. 1921,
Ph.D. 1926) Fund 1970.381

Arethusa, the beautiful nymph who scorned the love of Alpheus the river god, is featured on this fourth-century silver coin minted at Syracuse, as the letters under the chariot on the reverse indicate. A myth told the story of how Arethusa escaped from the advances of the god by fleeing to Syracuse, where she was changed into a spring.

Every Greek city-state had its own coinage and distinctive emblem. For example, above the chariot is the *triskeles*, "triple legs," an emblem of three-cornered Sicily. The task of presenting so much information within the small compass of a coin fell to a class of highly skilled metalworkers. Artists' signatures often appear on the obverse; the letters *NK* under the head of Arethusa have led some scholars to believe that they are the initials of the artist's name.

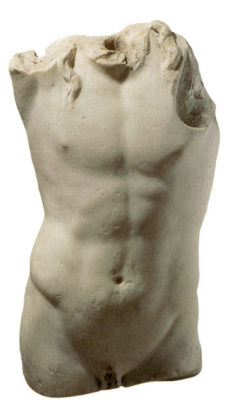

Torso of Dionysos
Rome, copy of a Greek 4th-century B.C. original
Marble, 36 in. high (91.5 cm)
Gift of Benjamin F. Vaughn, III (A.B. 1963),
in memory of Dr. Hazel D. Hansen 1963.60

A late republican or early imperial Roman copy of a Greek original, Stanford's marble torso was given to the Museum in memory of a professor of classics by an appreciative student. Right hand raised, weight on the right leg, with a suggestion of curls on the shoulder, the sculpture reproduces a Praxitelean original of ca. 365 B.C. Although the figure is similar to other known replicas of the resting Dionysos, it is also possible that the original may have been an Apollo. The type is not uncommon; the standard reference for Greek and Roman statuary, Reinach's *Répertoire* (1904), reproduces a line drawing of the Stanford torso together with nine others under the general heading "hommes nus."

From the large square bolt holes on the back of the neck and near the arm breaks, it is thought that drapery was once attached to the figure as a himation. But this element had been removed by the early nineteenth century when the torso was catalogued by Arcangelo Migliarini in 1839 with other objects in a Florentine collection.

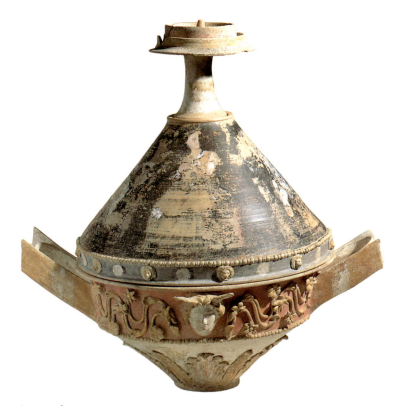

Lekane, 3rd century B.C.
South Italy, Centuripe
Polychrome terra-cotta with applied reliefs, 27⅜ in. high (69.5 cm)
Alice Meyer (A.B. 1905) Buck Fund 1981.44

This vase is a particularly fine example of the large, richly decorated wares made in the eastern Sicilian town of Centuripe in the third century B.C. Vessels from this town are notable for their unusual shapes and the elaborateness of their applied and painted ornamentation. This vessel, called a *lekane*, or lidded dish, originally stood on a pedestal, which is now lost. Most of the original finial is preserved and shows the neck and collar that at one time supported a crowning ornament, which was probably in the shape of another vessel or a statuette.

The painted decoration is unfortunately largely illegible, because the pigments were applied after the piece was fired and thus not made integral with the body. The figures that can still be discerned may commemorate stages in a girl's life, such as her betrothal or marriage. The applied decoration of vegetal forms, rosettes, and a Medusa head was affixed before the vessel was fired. Since both kinds of ornament appear on only one side of the *lekane*, such vases were most likely intended to be displayed in niches in the home or in tombs. The precise purpose of the *lekane* is not known.

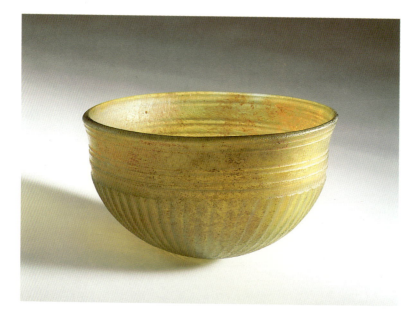

Fluted Bowl, 2nd–1st century B.C.
Eastern Mediterranean
Cast and ground glass, 4¾ in. diam. (12.2 cm)
Leland Stanford Junior Collection 17284

This golden bowl, purchased in Paris by Leland Stanford Junior in 1883, is a rare example of one kind of glass tableware in use during Hellenistic times. Cast in a two-part mold, the deep hemispherical vessel was given the subtle shaping of a lightly splayed rim. In simulation of a metal proto-type, vertical flutes and horizontal grooves were cut into it on a lathe, the entire surface then wheel-polished in-side and out. For the practical Ro-mans, the fabrication of glass—*artifix vitri*, as Pliny the Elder described it—was a busy activity centered largely in the eastern Mediterranean areas of Sidon and Tel Anafa near the Sea of Galilee. These manufactories were so productive that glass was being used as tableware in the first century B.C., while not long before, such vessels, which date back to pharaonic Egypt, had served solely as containers for such precious substances as kohl and perfume.

Of all the early crafts, the art of creating glass virtually from sand and soda was the most magical. Young Leland Stanford must have been in-trigued by it, for he acquired nine other examples of ancient glass made in a variety of ways—glass formed with a sand core, glass free-blown, mold-blown, and cut from the block—to add to his collection.

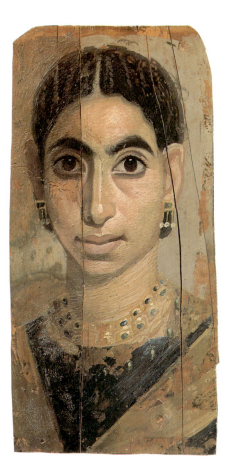

Portrait of a Woman, A.D. 160–225
Egypt, Fayum
Encaustic on cypress, 13⅝ in. high (34.7 cm)
Gift of Jane Stanford 22225

During the period of Egypt's occupa-
tion by the Romans, there developed
the practice of covering the face of a
mummy with a realistic portrait
painted on a thin wood panel. These
portraits, executed in a style wholly
Greco-Roman, took the place of tradi-
tional Egyptian mummy masks. The
technique of encaustic—that is, paint-
ing with wax-based pigments—
strikingly resembles the effect of
modern oil painting. In their individu-
ality and often poignant expressive-
ness, the best of the Fayum portraits
in fact seem "modern" and offer a
sharp contrast to the decorative for-
mality of traditional Egyptian style.

The Stanford Museum portrait,
from a cemetery at Hawara in the
Fayum, is closely datable by its hair-
style and general conception to the
late second century. It is clearly the
work of an artist of superior ability.

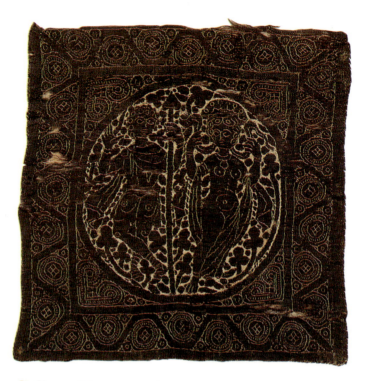

Venus and Aeneas, A.D. 4th century
Egypt, Coptic
Wool and linen, 9⁷⁄₁₆ × 9¼ in. (24 × 23.5 cm)
Gift of Timothy Hopkins 14711

Coptic, or Christian Egyptian, textiles give us a rare and suggestive glimpse of clothing worn throughout the Roman Empire in the centuries following the birth of Christ. Egyptian weavers produced fabrics not only for the Roman army occupying the Nile valley but also for export throughout the Mediterranean. Because of Egypt's dry climate, fragments of these weavings have survived in burial sites where the ancient dead lay wrapped in the garments of everyday.

This square panel with a design of Venus and Aeneas was found in the region of the Fayum lake sixty miles south of Cairo by the famous British Egyptologist Sir Flinders Petrie around 1890. Shortly afterward, it was purchased from Petrie, together with more than two dozen other examples, by Timothy Hopkins, an enthusiastic supporter of the Stanfords' new Museum. A further gift in 1947 by Mr. and Mrs. Charles de Young Elkus has made the group of early Coptic textiles at Stanford an unusually fine collection.

EUROPEAN AND AMERICAN PAINTINGS AND SCULPTURE

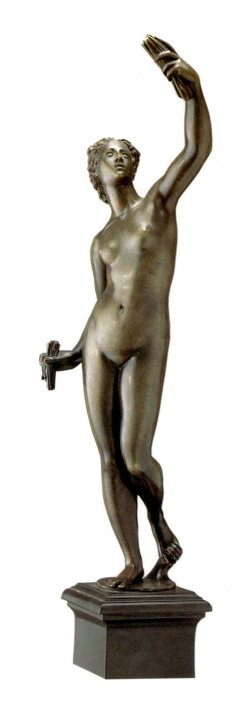

Antonio Susini (Italy, d. 1624)
Fortuna, ca. 1600
Bronze, 18¼ in. high (46.3 cm)
Gift of Mrs. Edgar Bissantz 1962.235

In each hand of Stanford's honey-colored little bronze *Fortuna* there is a fragment of the drapery that would, if complete, float over her head and remind us that fortune, like the wind, takes sudden turns. Personifications of the goddess of chance as Venus Marina standing above the ocean occurred often in the imagery of the late sixteenth century. Indeed, this version, which is identical to bronze statuettes at the Louvre and the Metropolitan Museum of Art, was the creation of Giovanni Bologna (1529–1608), the most important mannerist sculptor after the death of Michelangelo.

Bologna's work was so much in demand throughout Europe that he trained many assistants in Florence in the tricky specialities of casting and finishing his originals by the lost-wax method. The most accomplished of these younger sculptors was Antonio Susini. Court documents discovered during the 1970s have convinced scholars that the Stanford statuette was fabricated by Susini after an original made by Bologna around 1565.

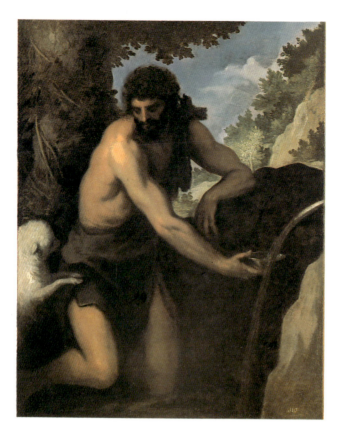

Jacopo Negretti, called Palma Giovane (Italy, 1544–1628)
Saint John the Baptist
Oil on canvas, 47¾ × 37⅞ in. (121.3 × 96.2 cm)
Committee for Art Fund in memory of Sylvia Kane Gray 1966.73

Palma Giovane, the leading painter in Venice around 1600, was profoundly influenced by Titian, Tintoretto, and Veronese, the great trio of sixteenth-century masters. His *Saint John the Baptist* shows us both the figural idiom of the Venetian High Renaissance—its painterly depiction of form—and the characteristically chromatic atmosphere that suffuses and unifies the composition.

Formerly in the collection of a member of the Hapsburg family, the painting has an illustrious provenance.

It was among an important group of Italian pictures brought to Brussels by Archduke Leopold Wilhelm, Spanish governor of the Low Countries from 1647 to 1656. Leopold's court painter, David Teniers the Younger, copied it in preparation for an illustrated catalogue of the archduke's collection, which was one of the first books of its kind. The handsome folio volume, *Schilder-Thooneel van David Teniers . . .* (1660), was acquired for the Museum's library of illustrated books in 1981.

Cornelis van Dalem (Flanders, 1535–1576)
and Jan van Wechelen (Flanders, active before 1557)
Landscape with Adam and Eve, ca. 1564
Oil on panel, 29¾ × 37⅞ in. (75.6 × 96.1 cm)
Gift of Mr. and Mrs. Prentis Cobb Hale (A.B. 1933) 1959.72

Adam and Eve in a pastoral landscape with both domestic and wild beasts suggests the innocence of Genesis I—the golden age before the Fall. Curiously, however, this sixteenth-century painting also includes the children of the first man and woman and hence should describe a less peaceful scene after the Expulsion. The same startling ellipsis occurs in other Flemish paintings of this period, and particularly in those by painters in the Antwerp circle of Cornelis van Dalem and Jan van Wechelen.

Characteristic, too, is the practice of combining in one composition the work of two specialists—in this case, van Wechelen's figures and van Dalem's landscape. The graphic precision of the trees and bushes reflects the latter's knowledge of paintings by Jan Mostaert and Albrecht Dürer, while the subtly nuanced atmospheric perspective evidently derives from van Dalem's own visual acuity. A rare example of his work with van Wechelen, van Dalem's *Landscape with Adam and Eve* is one of only six other known collaborations with that artist, among them, panels at the Prado and the Louvre.

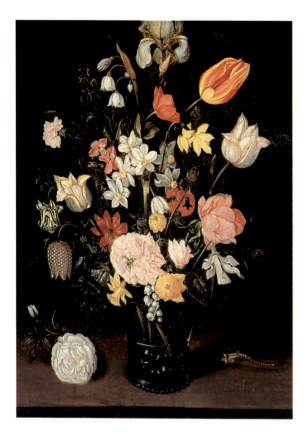

Ambrosius Bosschaert the Elder (Flanders, 1573–1621)
Flowers in a Glass Vase, ca. 1615
Oil on panel, 21¼ × 15½ in. (54 × 39.5 cm)
Committee for Art Fund 1983.279

Toward the end of the sixteenth century, Dutch and Flemish artists began to develop the floral still life as a subject independent of religious imagery. Though the Christian symbolism of the rose, the iris, and the columbine may linger in this early example, the dominant meaning of Bosschaert's glowing bouquet is that of the botanical record. It was painted at a time when the tulip and the fritillaria were being introduced to Europe from discoveries newly made in Persia and Turkey and were still considered exotic rarities.

Since roses and tulips do not bloom at the same time, we may question whether the flowers were painted from life. The answer can be found in the artist's method of making precise drawings of flowers during their brief bloom and using them as the basis of the permanent picture. That explains why we repeatedly see specific blossoms exactly as they are depicted here—the down-pointing daffodil, the golden ranunculus, the cyclamen, and the black-and-white fritillaria—in other floral pieces by this artist.

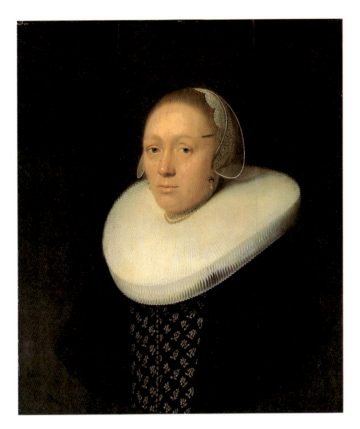

Pieter Nason (Holland, 1612–1688)
Maria Bogaert, 1641
Oil on panel, 30 × 25½ in. (76.2 × 64.7 cm)
Bequest of Mr. and Mrs. Stewart M. Marshall 1970.88

The inscription on the verso of this painting gives the sitter's name and identifies her as the wife of one Otto van Vollenhoven, while the signature and date of 1641 reveal that the portrait is an early work by Pieter Nason, an artist whose biography is still sketchy. A pendant portraying the husband is in the Warsaw National Gallery.

The style of the portrait—its subdued palette, the linear precision and dry elaboration of detail, the subtle modeling of the face in diffuse light— suggests practices of painters working in Amsterdam in the circle of Nicholas Eliasz. Pickenoy. Thus we may infer that Nason spent time in the prosperous capital city before taking up residence in The Hague, where his courtly portraiture of the 1660s is better known. But Nason's van Dyckian aristocrats do not engage the viewer as suggestively as does this burgher's wife with her deferential yet searching gaze and her aura of moral rectitude and strength.

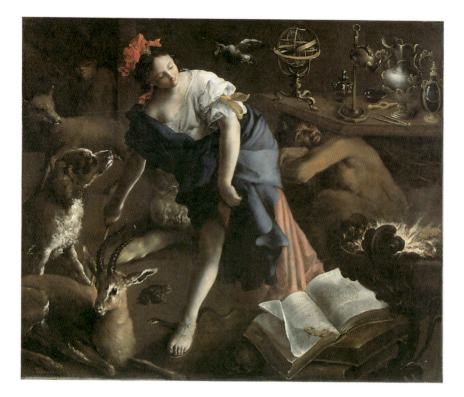

Bartolomeo Guidobono (Italy, 1654–1709)
Circe the Sorceress, ca. 1680
Oil on canvas, 61¼ × 73¼ in. (155.5 × 186 cm)
Alice Meyer (A.B. 1905) Buck Fund 1980.200

An elegant and graceful spirit was introduced to Genoese painting in the late seventeenth century by the artistry of Bartolomeo Guidobono. And this painting of a sweet-faced enchantress working her magic takes its place among his most ambitious compositions. Many of Guidobono's Genoese contemporaries favored the theme of the sorceress, for it offered a wonderful opportunity for the exercise of fantasy, the painting of animals, and the depiction of still life.

Yet the identity of the sorceress is not entirely clear. Scholars have made several suggestions, none of them conclusive. Guidobono's subject may be Circe transforming the companions of Odysseus from Book X of Homer's *Odyssey*, or she may be Alcina transforming her lovers from Tasso's *Orlando Furioso*. Still another suggestion is Medea rejuvenating the father of Jason. Such questions of identification are fundamental to the discipline of art history.

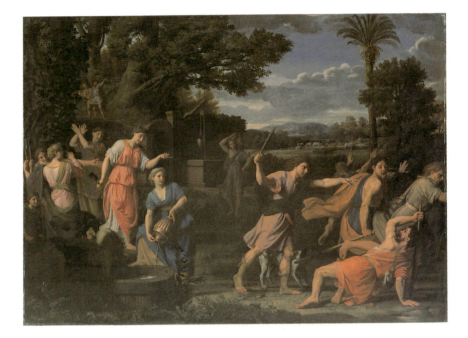

Nicolas Colombel (France, 1644–1717)
Moses Defending the Daughters of Jethro, ca. 1690
Oil on canvas, 48⅜ × 67⅞ in. (122.9 × 172.5 cm)
Committee for Art Fund 1980.43

This important canvas by Nicolas Colombel was inspired by a lost original of the same biblical subject, known only through drawings and engravings, by the French master Nicolas Poussin. It shows Moses driving shepherds away from a well that was used by the seven daughters of the priest Jethro to water their flocks. In gratitude Jethro gave Moses one of his daughters in marriage. Here, Colombel has reversed the orientation of the figures in Poussin's painting and made other slight changes in the composition, but he has retained the friezelike arrangement, the cool theatricality, and the crisp linear design that distinguished the style of his famous predecessor. Colombel was the last of Poussin's near contemporaries to emulate his style; by the time he painted *Moses Defending the Daughters of Jethro*, classicizing tendencies were out of fashion, not to be revived for another hundred years. The landscape, however, is Colombel's own invention, and into it he has set the palm tree that was to become a kind of signature for his work.

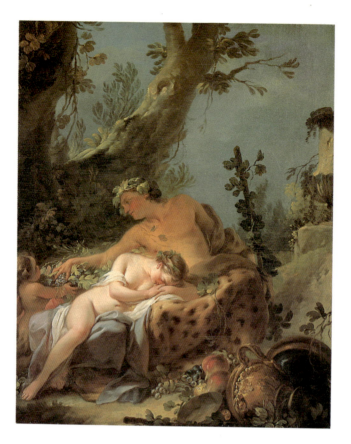

Jean-Baptiste-Marie Pierre (France, 1714–1789)
Bacchus and Ariadne, 1754
Oil on canvas, 31 × 25 in. (78.3 × 63.5 cm)
Committee for Art Fund 1971.37

From classical times, the grand mythologies of the loves of the gods
have accommodated paintings of the nude. Artists of the rococo
period delighted in the genre, often choosing adolescents as their
models rather than the mature men and women earlier ages had
preferred. Painters like Jean-Baptiste Pierre, the rival of François
Boucher and his successor as First Painter to the King of France, ex-
tracted from these scenes all the sensuousness they would yield, here
contrasting the soft and supple form of Ariadne with the bronze mus-
cularity of Bacchus, god of wine.

Admired throughout the century, paintings of nudes finally
prompted the critic Denis Diderot to remark that he had seen enough
of "tits and behinds—these seductive things interfere with the soul's
deeper feeling by troubling the senses." He looked for an art that
would inspire virtue and purify manners.

Claude Michel, called Clodion
(France, 1738–1814)
Girl Gathering Fruit, ca. 1790
Terra-cotta, 17 in. high (44 cm)
Alice Meyer (A.B. 1905) Buck Fund
1981.162

Statuettes of nubile girls making sacrifices or offerings were one of the French sculptor Clodion's frequent themes. This figure of a girl, with slightly faunlike features, who has unself-consciously gathered up fruit in her shift, is a characteristic example. The vivacity of the rococo is here combined with both a chastened naturalism and a touch of neoclassical coolness. The adolescent firmness of the thighs and breasts exemplified by this figure reflects the late eighteenth century's turning away from the dimpled opulence of Boucher's nudes.

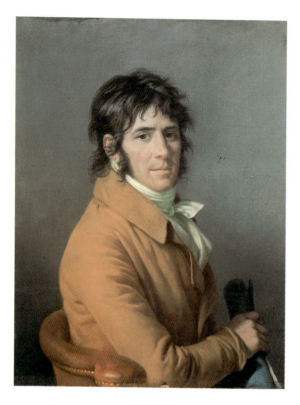

Marie-Gabrielle Capet (France, 1761–1818)
Joseph Chénier, ca. 1798
Pastel, 27½ × 22½ in. (69.8 × 57.1 cm)
Gift of Mortimer C. Leventritt (A.B. 1899) 1941.305

This flattering portrait of Joseph Chénier (1764–1811), brother of the poet André Chénier, comes at the end of a century-long tradition in pastel portraiture. Fashionably turned out in redingote and cravat, Joseph comes astonishingly to life in Capet's practiced hands. Gabrielle Capet was the protégée of Adélaïde Labille-Guiard, a distinguished painter who had been a pupil of Maurice Quentin de La Tour, the greatest of the French pastel portraitists. It was Labille-Guiard who introduced Capet to the technique. Here, Capet deftly shapes her sitter's quick smile and ready glance in a composition whose cool colors and simple design signify the sobriety of neoclassical portraiture.

A promising young painter from Lyons, Capet went to Paris in the early 1780s. Labille-Guiard, determined to promote the artistic careers of women, provided both studio instruction and a home for her and eight other young women. An ardent revolutionary, Labille-Guiard undoubtedly shared with them her zeal for the new society. Capet's sympathetic portrait of Chénier, a Jacobin author of an anti-royalist play that contributed to the events of 1789, reflects not only a brilliant artistic style but also the humanitarian impulse of the new day.

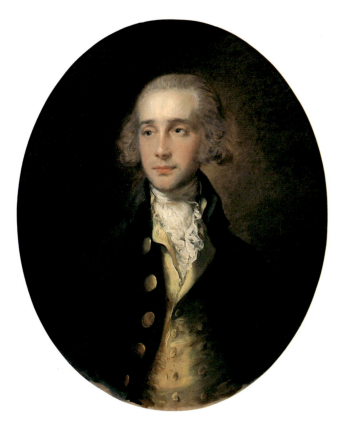

Thomas Gainsborough (England, 1727–1788)
James, Viscount Maitland, ca. 1780
Oil on canvas, 28¼ × 23¼ in. (71.8 × 59 cm)
Committee for Art Fund 1976.304

Portraiture was the most popular genre of painting in eighteenth-century England. Painters excelled in capturing the likenesses of the upper-middle class and aristocracy in flattering poses and costumes. This late work by Gainsborough numbers among other impressive portraits in the Museum's collections by Gavin Hamilton, Thomas Lawrence, Joshua Reynolds, George Romney, and Joseph Wright of Derby.

In Gainsborough's last period he painted many bust-length portraits of less than life size, presented in feigned ovals (the canvas of this work, beneath the fine, original frame, is actually rectangular).

The wan elegance and melancholy countenance that Gainsborough gave young Maitland (1759–1839), then in his early twenties, is somewhat deceptive: the sitter was, in fact, a violent-tempered, shrewd, eccentric man, an aggressive debater, and an unscrupulous politician. He entered the House of Commons in 1780 and was elevated to the House of Lords as earl of Lauderdale. An enthusiastic supporter of the American and French revolutions, he fought a bloodless duel with Benedict Arnold.

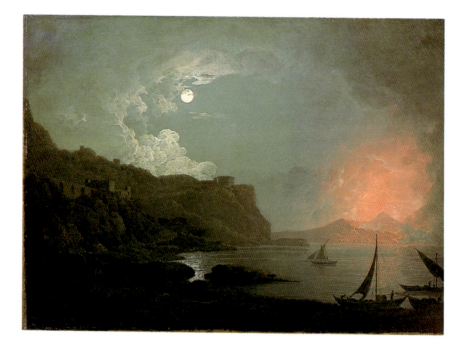

Joseph Wright of Derby (England, 1734–1797)
Vesuvius from Posillipo by Moonlight, ca. 1774
Oil on canvas, 16¹⁵⁄₁₆ × 23½ in. (43 × 59.6 cm)
Committee for Art Fund 1984.202

Like many of his British contemporaries, Joseph Wright of Derby combined a romantic sensibility with an interest in science. His particular preoccupation was with effects of light, and in many of his landscapes and interiors it is the light, or a combination of differently colored lights from several sources, that supplies the main drama.

While traveling in Italy in 1774, he witnessed an eruption of Mount Vesuvius, which deeply impressed him with its awesome beauty—or "sublimity," the eighteenth-century term for beauty mixed with terror. From memory he painted several versions of the scene, showing the eruption at night, contrasting the volcano's reddish glow with the silvery pallor of the moon and its reflections in the water of the bay. Years later, his memories of this spectacular nocturnal sight were reawakened by the furnaces and factories springing up around Derby, the advance guard of the Industrial Revolution. Moved by feelings of awe, like those that had caused him to paint Vesuvius, he now painted the factories of Wedgwood and Arkwright in the moonlight—windows ablaze and smoke rising from chimneys—as instances of industrial "sublimity."

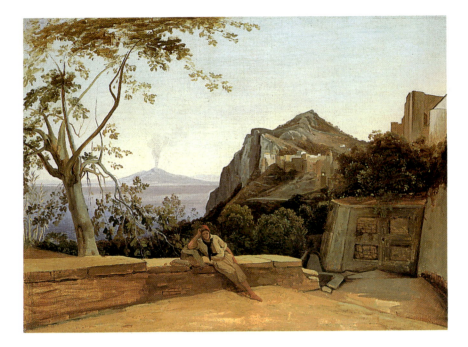

Théodore Caruelle d'Aligny (France, 1798–1871)
View of the Bay of Naples, 1834
Oil on canvas, 18⅜ × 26 in. (46.7 × 66 cm)
Committee for Art Fund 1978.164

Little known in this country, Aligny was one of Camille Corot's closest artist friends. They both traveled to Italy to seek inspiration and training in the land of classicism, and both toured France extensively searching for motifs. Beginning in 1822, Aligny exhibited regularly at the state-sponsored Salons, generally showing large pictures with historical or mythological subjects, such as *Prometheus on the Caucasus Mountains*. One of the first artists to paint in the Forest of Fontainebleau, Aligny sought to capture the light effects and atmosphere of a specific place.

This *View of the Bay of Naples* was most likely done in September 1834, on Aligny's second trip to Italy. From a vantage point on the island of Capri, it shows the place-marking cone of Vesuvius smoking in the background. Thinned paint, quickly brushed, marks out the geometries of the foreground parapet. Equally summary treatment is all that is necessary to suggest the sparse Mediterranean foliage. Pictures such as this one serve not only as exercises in notating a foreign light and place but also as homages to the classical past on which much of French culture is based.

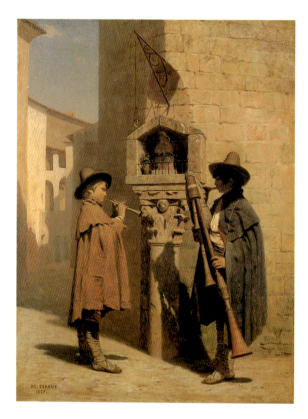

Jean-Léon Gérôme (France, 1824–1904)
The Pifferari, 1857
Oil on panel, 10 × 7⁷⁄₁₆ in. (25.4 × 18.9 cm)
Estate of Alice Meyer (A.B. 1905) Buck 1979.67

Italian peasant boys who traveled about playing their pipes for Christmas alms were attractive subjects for painters throughout the nineteenth century. In their picturesque garb, these *pifferari* brought the sounds and sights of bygone pastoral life into the gray cities of the industrial north. Thus the shepherd became a new, "progressive" theme in art. Here Jean-Léon Gérôme poses the young musicians before a simple shrine to the Virgin.

This little painting is unusual for Gérôme for reasons other than subject matter. He painted it out-of-doors and made a point of capturing the effect of strong sunlight and deep shadow on the forms; the reflected light is intensified by the glare of the stone wall that strengthens the silhouette of the boy at the right. Gérôme soon abandoned this kind of optical realism for the more controlled general light of the studio, going on to have an enormously successful career as the painter of exotica found in harems and slave markets.

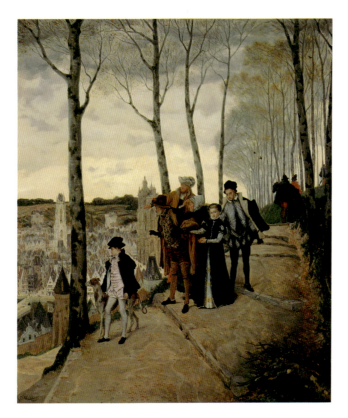

James Jacques Tissot (France, 1836–1902)
Promenade on the Ramparts, 1864
Oil on board, 20½ × 17½ in. (52.1 × 44.5 cm)
Gift of Robert Sumpf (A.B. 1940) 1968.107

The French artist James Jacques Tissot began his career as an imitator of Baron Henri Leys, a specialist in anecdotal costume pieces set, like *Promenade on the Ramparts*, in the period around 1500. Famous in later life for his stylish modern genre scenes, Tissot also admired the precise draftsmanship of Hans Holbein and the resonant colors of the early Flemish masters. The painting reflects these various influences and expresses the somewhat mannered romanticism of the still youthful artist.

Promenade on the Ramparts bears the date 1864, the first year Tissot entered a painting in the London Royal Academy exhibition; a few years later, he took up residence in England. The diarists Edmond and Jules de Goncourt, irritated by Tissot's snobbery and Anglomania, wrote of him: "This ingenious exploiter of English idiocy . . . has . . . a studio with a waiting room where, at all times, there is iced champagne at the disposal of visitors, and which is surrounded by a garden where, all day long, one can see a footman in silk stockings brushing and shining the leaves of the shrubbery."

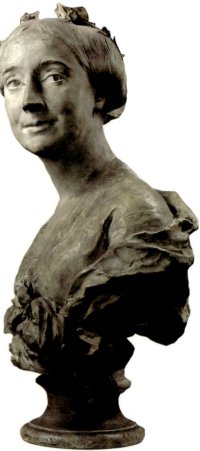

Jean-Baptiste Carpeaux (France, 1827–1875)
Madame de la Valette, 1871
Plaster, 28½ in. high (72.4 cm)
Purchased with funds given in memory of
Violet Andrews Whittier (A.B. 1924) 1978.17

Jean-Baptiste Carpeaux was the dominant French sculptor during the imperial epoch of Napoléon III. Gifted with a penetrating eye for the personal style of his sitters, he was much in demand as a portraitist by members of the court. Carpeaux's aristocratic portraits of leading figures of the Second Empire are among the most vividly evocative human documents of their era. Spontaneous and sensuous, they evoke all the drama of the baroque tradition that Carpeaux consciously revived.

The marquis de la Valette, of whose family our subject was a member, was first minister of the interior, and then minister of foreign affairs, before serving as French ambassador in London at the time of the Franco-Prussian War. The de la Valette family, along with Carpeaux, was in London after the French defeat, and it was there that Carpeaux executed this portrait. Nothing in its serene beauty betrays the recent collapse of Mme de la Valette's world, nor, for that matter, the anguish of the artist, who was at that time a refugee, tormented by illness and family misfortunes.

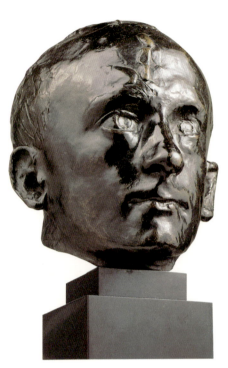

Auguste Rodin (France, 1840–1917)
Head of Baudelaire, 1892
Bronze, 1955, 8⅝ in. high (21.9 cm), George Rudier foundry
Gift of the B. Gerald Cantor Art Foundation 1985.16

Rodin began this portrait of Baudelaire in 1892 as a commission for
a cemetery monument to the poet. Because Rodin had never met
Baudelaire, he worked from photographs and a live model who re-
sembled him. Rejecting the idea of a statue, Rodin instead portrayed
a man who, in the sculptor's words, "lived only by his brain." Rodin
showed the poet's "tormented" forehead, the eyes with their "look
of disdain," and the "sarcastic" mouth surrounded by the "fat" that
Rodin felt indicated the poet's "voluptuous appetites." Rodin's finish-
ing touch was to retain the lumps on Baudelaire's brow, the swollen
appearance of which suggests the power of the poet's expanding
thought.

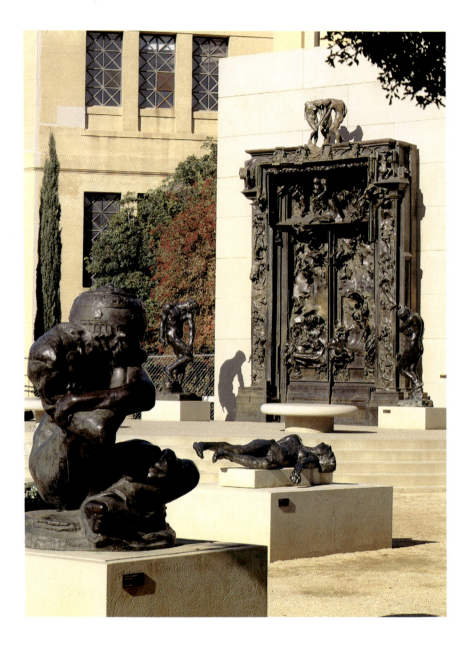

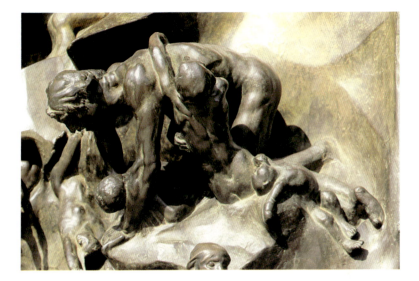

Auguste Rodin (France, 1840–1917)
The Gates of Hell, 1880–1900
Detail: *Ugolino and His Sons*, from the right door
Bronze, 1981, 20 ft. 10¾ in. high (6.37 m), Coubertin foundry
Gift of the B. Gerald Cantor Art Foundation 1985.86

In 1880 the French government commissioned this work to serve
as the entrance to a proposed museum of decorative arts; by 1900
Rodin completed his masterpiece, *The Gates of Hell*. Rodin began the
project as an interpretation of Dante's *Inferno* in a format inspired by
Ghiberti's *Gates of Paradise* but then chose to render hell as a condition
rather than as an illustration to a literary source. In doing so, he ef-
fected an unprecedented union of sculpture and architecture. Domi-
nated by *The Thinker*, who represents the artist in the moment of
creating a vision of life and art, *The Gates* presents an image of hu-
manity fated to exist through time both without hope and enslaved
to passion. The portal was not cast in bronze until ten years after
Rodin's death. Stanford's cast, the most exact and beautiful of the five
extant bronzes, is the focal point of the B. Gerald Cantor Rodin
Sculpture Garden of life-size bronzes. More than one hundred smaller
bronzes and plasters, as well as prints, drawings, and contemporary
photographs of Rodin's studio, are in the Museum's collection.

Charles-François Daubigny (France, 1817–1878)
Valley of the Arques, Normandy, ca. 1871–75
Oil on canvas, 24⅞ × 36¼ in. (63 × 92 cm)
Committee for Art Fund 1982.201

Born in Paris to a family of artists, Daubigny spent his childhood in
the village of Valmondois beside the Oise River, and forever after re-
membered the delights of his boyhood. Occasionally, he worked with
the naturalist painters of the Barbizon School among the rocks and
woods near Fontainebleau but greatly preferred the scenery of the
familiar river courses with their banks of verdure and vast skies.
Attracted to nature's varying moods, Daubigny became increasingly
absorbed by the problem of fixing visual impressions—shadows cast
by storm clouds and colors filtered by the rain—as we see in this
painting of pastureland beside the river Arques. Less interested than
the Barbizon masters in the inner life of nature, he sought to render
what he saw with vivacity and truth. In his free handling of pigment,
Daubigny was an influence on the impressionists, and also their cordial
friend and supporter.

William Keith (United States, 1838–1911)
Upper Kern River, 1876
Oil on canvas, 75⅛ × 123¼ in. (191 × 314 cm)
Gift of Jane Stanford 12057

"I am going to study altogether from Nature," William Keith wrote from Paris after seeing paintings by artists of the Barbizon School. Returning to California from a year abroad, he set out to sketch the Sierra Nevada in 1872 with the great naturalist and mountaineer John Muir, a fellow Scot and Keith's exact contemporary. But sketching on the Pacific slope differed from sketching in the Forest of Fontaine-bleau. "Traveling about in the Sierra," Keith wrote, "one has to undergo a good deal of hardship and keep it to one's self." Especially so if one hiked with Muir, whose powers of endurance were mythic. Yet climbing with him led the way to Keith's coloristic visions of the sublime, and the western romantic landscape reached its apogee during the 1870s in monumental canvases inspired, like this one of the Upper Kern River, by the grandeur of California's mountains.

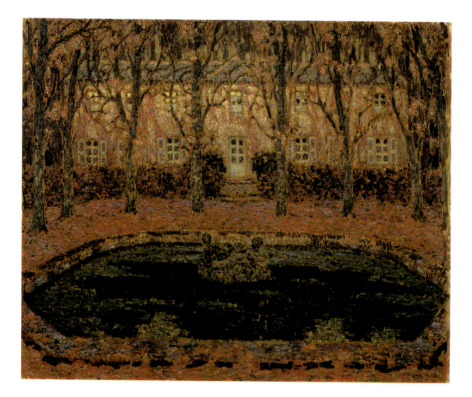

Henri Le Sidaner (France, 1862–1939)
The Garden of the Gerberoy House, ca. 1905
Oil on canvas, 23⅞ × 28⅞ in. (61 × 74 cm)
Gift of Joseph Bransten 1968.1

The French artist Henri Le Sidaner frequently used the garden of his country house at Gerberoy as the subject of his work, building up the painted surface in little color patches without the use of line. This neo-impressionist technique preserves the illusion of form while flattening out spatial depth and creating a misty, dreamlike aura. In this painting the artist has used divisionist swipes of color to suggest a twilight setting for his leafless trees and deserted pool. The haunting imagery that results lifts an ordinary house from document to symbol. In the distance one seems to hear the melancholy strains of Verlaine's "violons de l'automne."

An artist dear to Proust, Le Sidaner was one of several whom the novelist drew upon for the creation of the painter Elstir in *A la recherche du temps perdu*. Monet and Whistler were among the other artists, fitting associates for Le Sidaner, whose work stems from both realist and symbolist sources.

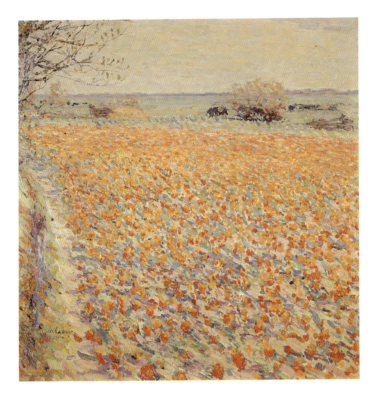

Joseph Raphael (United States, 1869–1950)
Holland Tulip Fields, 1913
Oil on canvas, 29½ × 29½ in. (75 × 75 cm)
Gift of Morgan Gunst (A.B. 1906) 14931

By the early years of the twentieth century, American Impressionism, with its cheerful palette and convincing subject matter, had taken on distinctive regional forms. In California, artists in San Francisco augmented the decorative style they had learned from Arthur Mathews with French techniques gleaned from study in Paris. Joseph Raphael's painting *Holland Tulip Fields* shows the results in a composition held together by solidly constructed design, recognizable space, and beguiling effects of color. Raphael's free, almost expressionist, handling helped to shape the work of Oakland's Society of Six.

A San Franciscan by birth, Raphael studied at the California School of Design (now the San Francisco Art Institute) with Mathews and Douglas Tilden before entering the Ecole des Beaux-Arts in Paris in 1903. Shortly later he married a Dutch woman and lived near Uccle in Holland for many years, continuing to sell his paintings in the United States with the help of Albert M. Bender, one of San Francisco's great patrons of the arts.

"harmonies based upon lines, volumes & planes"

NOT

narrative, naturalistic

Raymond Duchamp-Villon (France, 1876–1918)
Torso of a Young Man, 1910
Bronze, posthumous cast, 21⁵⁄₁₆ in. high (55 cm), George Rudier foundry
Committee for Art Fund 1969.83

The lunging stride of this powerful figure carried new ideas about sculpture to the twentieth century when it was first exhibited in its original plaster at the famous New York Armory show in 1913. For Raymond Duchamp-Villon, sculpture no longer meant the sentimental imitations of the human model that the late nineteenth century found so appealing; rather, it meant "harmonies based upon lines, volumes and planes." Like other early modernists, Duchamp made conscious use of ancient Greek figure types as well as new cubist ones. A crystallization of his innovative concepts, the *Torso*'s simplified anatomy is constructed in logical, rhythmic forms to carry the expressive quality without narrative reference.

After the artist's premature death in World War I, his brother Jacques Villon had a bronze cast of the figure made by Georges Rudier. The Stanford cast is seventh in the edition of eight, signed by both Rudier as founder and Louis Carré as editor. A related sculpture based on a life model suggests that the face constitutes an idealized likeness of Raymond's other brother, Marcel Duchamp.

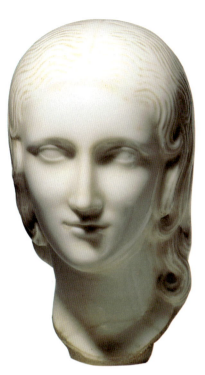

Elie Nadelman (United States, 1885–1946)
Ideal Head, ca. 1916
Marble, 14 in. high (35.5 cm)
Museum Purchase Fund 1975.16

Early in the century, the Polish-born sculptor Elie Nadelman, working in Paris and New York, produced a series of idealized heads like this one. Its generalized form with flattened brow smoothly descending to the nose, eyes blank and perfectly shaped, and hair gently rippling close to the head repeats the firm contour and unified profile of Greek classical sculpture. The calm, balanced values of antique sources lent the formal harmony sought by many artists of the early twentieth century.

Yet Nadelman maintained that his heads were based on principles of plastic construction entirely his own. He composed these curves, he wrote, "so as to bring them into accord or in opposition to one another—in that way, I obtain the life of form." However that may be, Nadelman shared with the Greeks an intellectual ideal of beauty—a form of musical geometry. In their glossy perfection and eerie sweetness, Nadelman's sculptures of Ideal Heads are the last, most extreme products of an investigation into form that began in Greece centuries ago.

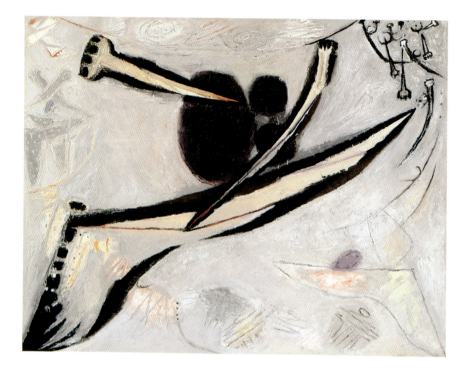

Frank Lobdell (United States, b. 1921)
Untitled, 1964
Oil on canvas, 69⅜ × 90 in. (176 × 229 cm)
Gift of the artist 1990.52

The syntax of visual forms in the paintings of Frank Lobdell seems at first glance so marked by personal association as to be indecipherable. Here, enigmatic shapes, neither abstract nor identifiably figurative, heavily outlined in black, gyrate against a ground of radiant white, ruggedly worked and touched faintly with pink. With careful study, however, Lobdell's rhythmic forms become animated, seeming to move suggestively through energy fields of the artist's devising. What was ambiguous and baffling comes to life in the viewer's imagination through the language of form, unmindful of words.

The lifting of the personal into the symbolic is one of the goals of art. And throughout his life as an artist, Frank Lobdell, Wattis Professor of Art at Stanford since 1965, has kept to this transformation with single-minded dedication, working in a style that the critic Thomas Albright once described as "somber, dramatic, agonized, and grave."

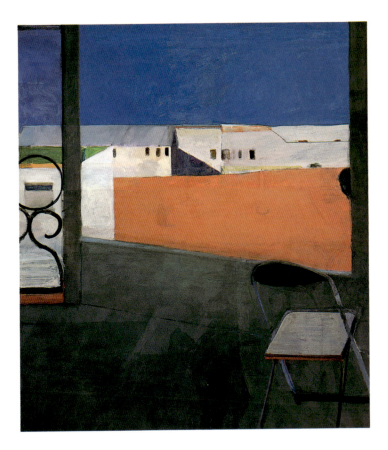

Richard Diebenkorn (United States, b. 1922)
Window, 1967
Oil on canvas, 92 × 80 in. (234 × 203 cm)
Gift of the artist and his wife and anonymous donors 1969.125

In this painting of 1967, Richard Diebenkorn renders the blue sky and water beyond the balcony window of his Santa Monica studio in broad open areas of color that are at once abstract and figurative. The intensely saturated colors, the tight spatial play of forms, and the curvilinear form reminiscent of Mediterranean balcony railings remind us of Diebenkorn's debt to Henri Matisse, the great French modernist.

Diebenkorn, who finished his undergraduate studies at Stanford in 1943, was one of many young artists whose formative years were influenced by the studio courses of Daniel Mendelowitz. It is of special interest to note, moreover, that during these years, Mendelowitz took him to meet Sarah Stein, then living in Palo Alto, to see the paintings by Matisse that she had brought back from Paris.

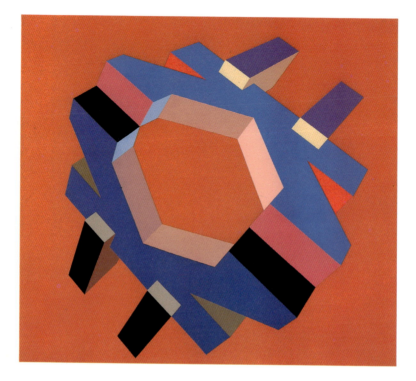

Miriam Schapiro (United States, b. 1923)
Docking #1, 1969
Acrylic on canvas, 72 × 80 in. (183 × 203 cm)
Committee for Art Fund 1971.19

This painting belongs to a series of computer-generated paintings and
drawings Miriam Schapiro made in 1969, just two years before she
and Judy Chicago began the history-making Feminist Art Program
at the California Institute of the Arts in Valencia. Schapiro spent her
early career as an abstract artist, first in the abstract expressionist
mode and then in a tighter and more minimalist style. In 1969, hav-
ing moved to La Jolla, California, she worked with a physicist to de-
velop a computer program that turned her drawings into designs for
paintings. Here the spatial illusionism was generated electronically,
but the vibrant colors and glow of light are enduring hallmarks of
this artist's work.

EUROPEAN AND AMERICAN PRINTS, DRAWINGS, AND PHOTOGRAPHS

Albrecht Dürer (Germany, 1471–1528)
The Virgin and Child with the Monkey, ca. 1498
Engraving, 7½ × 4¾ in. (190 × 120 mm)
Gift of M. Donald Whyte 1980.131

This exceptionally fine impression of Dürer's rendering of the Virgin and Child, a theme to which he returned frequently and always with eloquence, is part of the small group of engravings and woodcuts by that artist in the Museum's collection. This early engraving, from the final years of the fifteenth century, preserves the flavor of Dürer's Gothic heritage in the character and grace of the Virgin. Also Northern is the artist's close observation of nature, expressed in the grassy bank and distant landscape. The monkey, in Christian iconography a symbol of carnal pleasures, sits enchained, while in the Christ Child's hand rests a small bird, a symbol of purity of the soul.

Et famulū tuū epiſcopū noſtrū cū oib° ſibi cōmiſſis ab omni
aduerſitate cuſtodi: τ pacē eccleſie tue nr̄is cōcede tēpozib°.

Master D. S. (active in Basel, ca. 1503–1515)
Christ on the Cross between Mary and Saint John, 1506
Woodcut, printed on vellum, hand-colored, 10¼ × 6¼ in. (260 × 159 mm)
Alice Meyer (A.B. 1905) Buck Fund 1982.319

The woodcut, the oldest and simplest form of printmaking, came
from China and later was introduced into Europe. The earliest sur-
viving examples, from the end of the fourteenth century, were pri-
marily made for sale to religious pilgrims. Although dating more
than a century later, the Stanford woodcut continues the tradition of
powerful holy images. The design is by an unknown artist, identified
only by his monogram that appears on but a few of his prints.

Few early woodcuts have survived, for generally they were used
as objects of daily worship; some were bound into books or pasted
into chests. The Stanford impression was printed on precious vellum
and carefully colored by hand before being bound in the *Missale Ca-
minese*, opposite the text of the canon of the mass. This rare missal
was printed for a bishopric in Pomerania by the printer G. Stuchs.

Marcantonio Raimondi (Italy, ca. 1475/80–after 1527)
The Reconciliation of Minerva and Cupid, ca. 1517–20
Engraving, proof impression from the unfinished plate, with
extensive work in pen and brown ink, 8 × 4½ in. (206 × 115 mm)
Committee for Art Fund 1969.120

This unique proof impression, with a free sketch of a striding figure on the reverse, is by the prolific Italian engraver Marcantonio Raimondi. Long considered, with Dürer and Lucas van Leyden, one of the three great Renaissance printmakers, only Marcantonio worked exclusively as a reproductive engraver. His reputation was built on his interpretations of Raphael's designs. Although the artist and chronicler Giorgio Vasari was among the early admirers of Marcantonio's technical wizardry, he was able to offer little biographical information, and even today Marcantonio's birth and death dates are obscure—he evidently came from Bologna and returned there after the Sack of Rome in 1527.

The Stanford subject is based on a design by Raphael, which does not survive. It most probably represents the goddess Minerva but was earlier thought to be an allegory of peace. In this very rare example of Marcantonio's draftsmanship the artist has added details in pen and ink to the already engraved lines, which describe the tree trunk and billowing drapery.

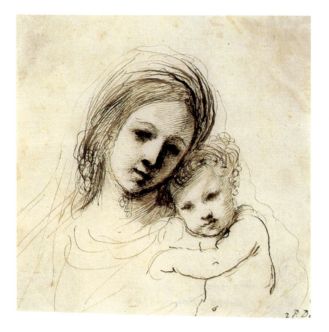

Giovanni Francesco Barbieri, called Guercino (Italy, 1591–1666)
Madonna and Child, ca. 1630
Pen and ink, 5 × 5 in. (127 × 127 mm)
Gift of Mrs. M. C. Sloss 1960.44.206

Figure studies and compositional plans predominate in the group of
Italian seventeenth-century drawings in the Stanford Museum. They
demonstrate the broad range of uses to which drawings were put,
from a rough sketch for a fresco in the Palazzo Barberini by Pietro da
Cortona and a large, finished presentation drawing of the vision of a
saint by Marc Antonio Francheschini, to designs for prints by Stefa-
no Della Bella and Giovanni Maria Tamburini. Guercino, one of the
most gifted and prolific baroque draftsmen, is represented by this
study that is related to a painting of the martyrdom of Saints John
and Paul. The Stanford drawing is characteristic of Guercino's rapid
pen notations in its smooth parallel strokes and grace of line. In
contrast to Herman Saftleven (see facing page), who worked for a
democratic city government, Guercino worked primarily for the
autocratic Catholic Church and aristocrats who demanded Counter-
Reformation imagery.

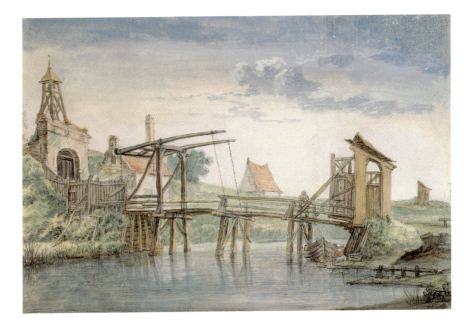

Herman Saftleven (Holland, 1609–1685)
View of the City Wall of Utrecht,
with a Canal and Bridge, ca. 1660–70
Watercolor and gouache over black chalk,
11⅞ × 17⅜ in. (300 × 440 mm)
Committee for Art Fund 1985.50

Landscape and portraiture gained in popularity during the seventeenth century in the Low Countries with the newly prosperous burghers. Herman Saftleven, who came from a family of artists, specialized in landscape. The city of Utrecht commissioned him to depict the environs of the city, its wall, towers, and canal. These chalk and gray wash studies, of which three hundred are known, are today in many collections, with a concentration in the Utrecht city archives. The Stanford watercolor, unusual for its large size and use of color, is among the later views; it was formerly in the collections of several noted drawing connoisseurs, among them J. P. Heseltine.

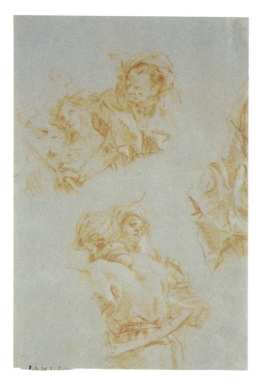

Giovanni Battista Tiepolo (Italy, 1696–1770)
Studies for the Würzburg Residence of Prince-Archbishop von Greiffenklau, ca. 1751–52
Red chalk, heightened with white, on blue paper,
15⅜ × 10¼ in. (390 × 262 mm)
Committee for Art Fund 1988.170

The magnificent frescoes by Giovanni Battista Tiepolo that decorate the stair hall and chapel of the archbishop's palace at Würzburg were the crowning achievement in the long and illustrious career of one of Venice's preeminent artists. The authorship of many of the preparatory studies for this immense project has long been debated, since both of Giovanni Battista's sons, Domenico and Lorenzo, assisted on this commission and made similar chalk studies. Recent scholarship has clarified the various purposes of these drawings, and it has been convincingly proposed that small sketches, like those on the Stanford sheet, were done by the father in mapping out the fresco activity of a particular day. These shorthand studies served in place of the more usual, but cumbersome, large-scale cartoons and were more attuned to the rapidity with which Tiepolo worked. Complementing these chalk studies in the Museum's collection are three pen and wash drawings by Giovanni Battista and three by Domenico—gifts of Mortimer C. Leventritt, who donated other fine Venetian works, in addition to Chinese ceramics and bronzes.

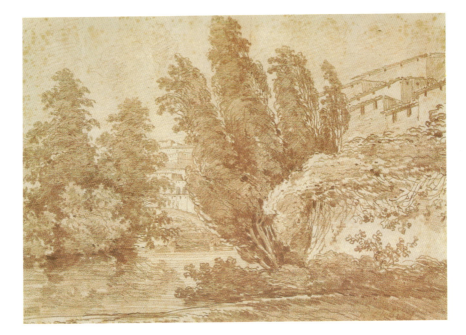

Hubert Robert (France, 1733–1808)
A Wooded Landscape, ca. 1760
Red chalk, 11½ × 16⅜ in. (293 × 416 mm)
Committee for Art Fund 1974.197

Red chalk, *sanguine* to the French, was a favorite medium of eighteenth-century draftsmen. In this sheet, Hubert Robert has applied the chalk in long, sensuous strokes on a rough oatmeal paper. This distinctive chalk often varied considerably in color and texture, as can be seen by comparing these two drawings by Tiepolo (facing page) and Robert—the one a series of notations by a master, the other a study from nature by a young artist.

Robert arrived in Rome in 1754 and spent a decade in Italy before returning to Paris. Roman ruins and architectural views remained his speciality, although in later years he also designed gardens. Robert and his better-known contemporary Honoré Fragonard often sketched together, and their red chalk drawings include several identical scenes. Since Fragonard spent much of the summer of 1760 at the Villa d'Este at Tivoli, it has been assumed that this drawing by Robert represents a view near those grounds, but this conclusion cannot be proven.

John Constable (England, 1776–1837)
Salisbury Cathedral, 1816
Pencil, 4⅜ × 3⅜ in. (112 × 86 mm)
Purchased with funds given in honor of
Robert E. and Mary B. P. Gross 1981.264

England's two great landscape painters, Constable and Turner, are represented in the Museum's collection by several works, among them two dating only a year apart. Constable made this pencil study of Salisbury Cathedral on October 4, 1816, on his way to the Dorset coast with his new bride. He first drew the cathedral in 1811, again five years later, and returned to the site during the 1820s. In addition to these drawings, the artist painted the massive Gothic cathedral on several occasions.

Constable shows us the southern transept behind a leafy tree, set against a lightly clouded sky. The artist spoke of the necessity of keeping a "close and continual observance of nature," a practice exemplified in this sheet. So accurately did he depict the shadows the piers cast on the different roofs that the time of day—late morning—can be determined. Accuracy was important to Constable, who sometimes noted the time as well as the date of a sketch, to remind him of specific effects.

Joseph Mallord William Turner (England, 1775–1851)
A Rainbow over the Rhine River, 1817
Watercolor, 8⅜ × 12¾ in. (214 × 325 mm)
Purchased with funds given by Josephine Grant McCreery
in memory of her parents, Joseph and Edith Grant 1972.59

Constable's small pencil sketches document the region he knew intimately—the Dorset downs and coast; Turner's watercolors of the Rhine, by contrast, reveal a vista new to him. After traversing England, Turner explored the Continent, filling notebooks with sketches which he later worked up into paintings or watercolors or which he used as models for engravings.

The story is told that Turner, upon returning to England, rushed to Farnley Hall in Yorkshire, the seat of his great friend and patron Walter Fawkes, and unrolled fifty-one watercolors of the Rhine, all of which Fawkes bought on the spot. The Museum owns two of these works, which are not large, fully finished exhibition pieces but smaller watercolors. In this Rhine view, a broad curve in the river is spanned by a rainbow, while in the other the ruins of a twelfth-century castle crowning a steep hill are silhouetted against the sky. In both, Turner has exploited the subtleties of watercolor technique in the atmospheric hazes that shroud the river.

Richard Parkes Bonington (England, 1802–1828)
Rue du gros horloge, Rouen, 1824
Lithograph, 9⅝ × 9¾ in. (245 × 250 mm)
The R. E. Lewis Collection of Bonington Prints and Books given in
memory of Dr. Alfred J. Goldyne by the Goldyne Family 1975.163.7

Bonington, most highly regarded for his watercolors and oils, is
important in the history of printmaking for his mastery of the new
technique of lithography. Stanford has virtually all of his sixty litho-
graphs, some in rare, early states. This view of Rouen's famous street
with its clock tower and half-timbered houses shows Bonington's
skill in rendering atmospheric effects, paired with a relish for ani-
mated street subjects. Rouen charmed many English artists who
passed through it on their way from Calais to Paris. Bonington, who
took several walking tours of Normandy, has left in his lithographs a
valuable record of its medieval past. Many of these prints, including
this, his most impressive street scene, were published in Baron Tay-
lor's encyclopedic publication, *Voyages pittoresques et romantiques dans
l'ancienne France.*

Louis-Auguste Bisson (France, 1814–1876)
Auguste-Rosalie Bisson (France, 1826–1900)
Caserne d'infanterie, Blois, ca. 1855–60
Albumen print, 13¹¹⁄₁₆ × 10⅛ in. (348 × 258 mm)
Museum Purchase Fund 1975.5

The Bisson brothers and their father established a daguerreotype portrait studio in Paris in 1840 called Bisson Père et Fils. Louis-Auguste was trained as an architect, and Auguste-Rosalie was a heraldic painter like his father. The three of them were the founding members of the Société Française de Photographie. The two brothers completed several large documentary projects during their career. In 1848–49 they photographed all nine hundred members of the National Assembly. From 1853 to 1862 they made architectural records, such as this one, for a publication entitled *Réproductions photographiques des plus beaux types d'architecture et de sculpture*. Their large plates allowed them to capture the various textures of the entrance to the infantry barracks—Gothic arches, rustications, and mullions. In 1860 the brothers were named official photographers to Emperor Napoléon III, and they accompanied him and Empress Eugénie on a tour of the newly acquired province of Savoy.

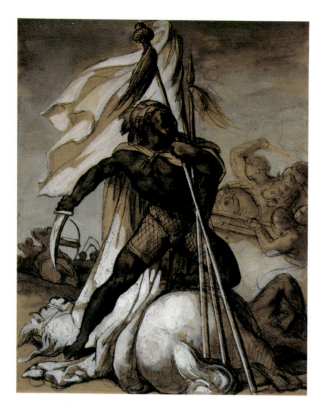

Théodore Gericault (France, 1791–1824)
The Black Standard Bearer, ca. 1818
Pencil, chalk, wash, and gouache, 8 × 6⅜ in.
(203 × 163 mm)
Mortimer C. Leventritt (A.B. 1899)
and Committee for Art Funds 1972.6

Most of Gericault's drawings are of purely exploratory character and were meant only for his private use. It is therefore something of a mystery why he produced some twenty drawings of exceptionally careful execution in the period between his Italian stay in 1816–17 and the start of his work on the *Raft of the Medusa* in 1818.

The Black Standard Bearer belongs to a small number of drawings that represent exemplary modern acts of courage or defiance taken from the Napoleonic wars, with the formality and elevation of style with which he had earlier treated classical themes. Its subject was suggested by Gericault's friend, Colonel Bro de Comères, a veteran of the French campaign on Haiti in 1801–03. The black warrior, monumentlike in his Michelangelesque pose, and perhaps intended as an imaginary portrait of either Toussaint or Dessalines, Haitian heroes against the French, sums up the spirit of the slave revolt. Not long after, Gericault was to place the figure of a black man at the apex of the *Raft of the Medusa* composition.

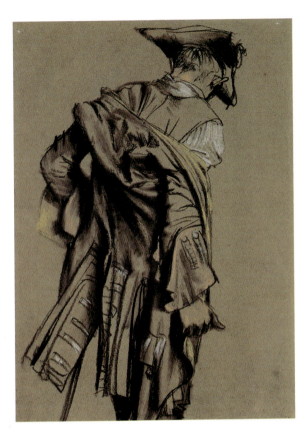

Adolph Menzel (Germany, 1815–1905)
A Model Putting on a Coat, ca. 1850–55
Charcoal and colored chalks, 9¼ × 6¾ in. (237 × 170 mm)
Mortimer C. Leventritt (A.B. 1899) Fund 1973.21

Prussia's prestigious history painter, Adolph Menzel, is not well known in this country since few of his works are in American museums. A master draftsman, Menzel began his career very early as a printmaker and book illustrator. During the 1840s and 1850s, he designed hundreds of prints for several large publications documenting the life of Frederick the Great of Prussia, a subject he later carried on in large history paintings. In researching this project, Menzel studied all aspects of eighteenth-century life, in particular its military dress.

The Stanford study is related to a three-volume publication devoted to these uniforms. From an unusual angle, Menzel has sketched the model with a heavy overcoat of the kind worn by an infantryman. Concentrating on the weight of the garment pulled across the upper back, he has emphasized its bulk in diagonal strokes and areas of rubbed charcoal. Menzel made a number of studies on colored paper and, like Gericault, used it as a middle ground against which he set dark outlines, to which he added highlights of color.

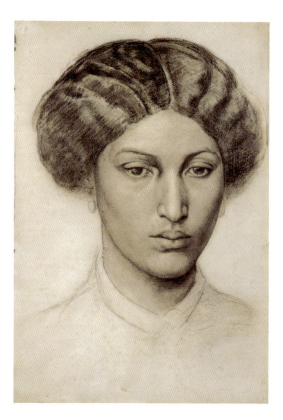

Dante Gabriel Rossetti (England, 1828–1882)
Head of a Woman (Mrs. Eaton?), ca. 1865
Charcoal and black chalk, 18⅜ × 12⅜ in. (466 × 314 mm)
Museum Purchase Fund 1970.390

The artists and poets who became known as the Pre-Raphaelites created an image of Woman, in their poems and pictures, that combined physical beauty with idealized sentiment. Rossetti's fair maidens, while personifying Christian virtue, are at the same time temptresses, and their features often are recognizable as the artist's current love. Rossetti's art, however, also contained a more realistic strain, as seen in this portrait, possibly of a Mrs. Eaton, who does not seem to have played an important role in the artist's life. It illustrates Rossetti's tendency to monumentalize the physical and psychological presence of a woman, when not sublimating her into an ethereal apparition. In a work such as this, the artist seems to express his relish for the powerful, brooding corporeality of the sitter.

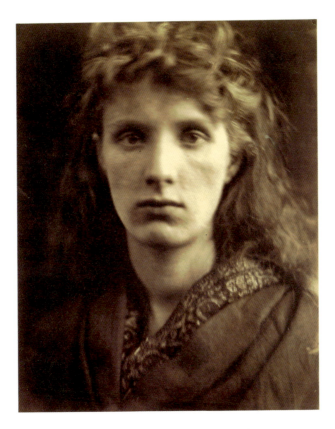

Julia Margaret Cameron (England, 1815–1879)
Mountain Nymph, Sweet Liberty, 1866
Albumen print, 14 × 11¼ in. (366 × 286 mm)
Museum Purchase Fund 1972.121

Julia Margaret Cameron began photographing at the age of forty-eight. She turned the energy that had fueled her earlier activities—serving as hostess to the British colony in Calcutta, philanthropies, and gift giving—to her "mortal, yet Divine" art of photography. Through the use of chiaroscuro, she revealed the character of her eminent Victorian subjects. This image of Cyllene Wilson, an orphan adopted by Cameron, is characteristic of the artist's romantic style of portraiture.

The astronomer Sir John Herschel, one of Cameron's close friends, called this portrait (whose title is taken from a line in Milton's *L'Allegro*), "a most astonishing piece of high relief. She is absolutely alive and thrusting out her head from the paper in the air." When it was appropriate to her subject, Pre-Raphaelite painting was echoed in Cameron's photographs. But her most abiding influences were those of the Italian old masters and of Rembrandt, whom she revered.

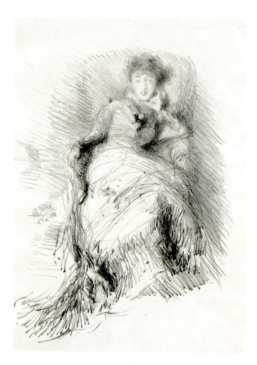

James A. M. Whistler
(United States, 1834–1903)
Study, No. 3, 1878
Lithograph, 10¾ × 8⅝ in.
(275 × 220 mm)
Museum Purchase Fund 1967.47

These three works offer a charming picture of the pleasures of daily life at the end of the nineteenth century. Whistler's lithograph of a woman gracefully relaxing in an armchair dates from a period of heady artistic and social success when, at his Chelsea residence embellished with blue-and-white Japanese wares, he stylishly entertained London society. Among his frequent visitors were the writer Oscar Wilde, the painter J. J. Tissot, and the beauty Lillie Langtry (who may have been the inspiration for this print). Cassatt's etching and drypoint of her mother with grandchildren reveals the intimacy of that household and the strength of family ties. Roussel, in his animated pen study of a Parisian park with nursemaids and children playing, takes the theme of domesticity into the out-of-doors, weaving a decorative tapestry.

None of these three works is well known, and each represents an artist working in a new way. Whistler had received high praise for his etchings before he undertook lithography in the late 1870s. This, his third attempt, was drawn directly on the stone. Printed in a small edition of only twelve impressions, this lithograph has a spontaneity not found in his more complex and calculated etchings.

Cassatt, who, initially, was not attracted to printmaking, admired Whistler's early etchings. When she learned to etch, under the tutelage of Degas, Pissarro, and Bracquemond, she too printed in small editions. Her drypoint is based on a painting shown in the sixth impressionist group exhibition of 1881.

Roussel's preparatory design, squared for transfer, was further developed in three works: an oil, a large decorative panel, and a lithograph. These were early projects of the young Nabi painter, freshly charged by the catalyst of Japanese prints. Japanese influence also played a crucial role in Cassatt's color aquatints and Whistler's nocturnes.

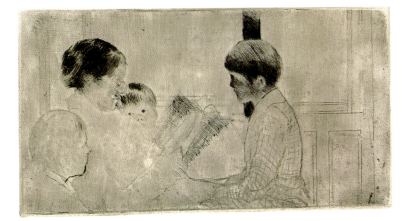

Mary Cassatt (United States, 1845–1926)
The Artist's Mother Reading to Her Grandchildren, 1880
Soft-ground etching and drypoint, 6⅜ × 11¾ in. (160 × 300 mm)
Gift of Marion E. Fitzhugh and Dr. William M. Fitzhugh (A.B. 1930)
in memory of their mother, Mary E. Fitzhugh 1963.5.10

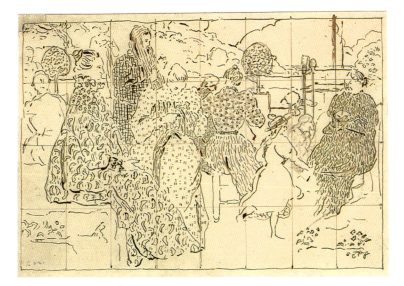

Ker-Xavier Roussel (France, 1867–1944)
Women and Children in a Park, ca. 1890–92
Pen and ink over pencil sketch, squared for transfer,
7⅞ × 12 in. (200 × 305 mm)
Museum Purchase Fund 1971.32

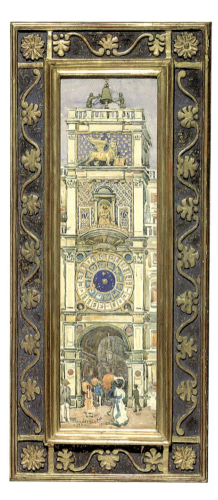

Maurice Brazil Prendergast
(United States, 1864–1924)
*The Clock Tower in St. Mark's Square,
Venice*, 1911
Watercolor, in a frame designed by
Charles Prendergast, 22¼ × 6¼ in.
(570 × 160 mm)
Gift of Mrs. Stephen Greene
(Janet C. Gould, A.B. 1941) 1984.88

Prendergast's watercolors delight us
with their festive air. Many of his
scenes celebrate public gatherings and
family outings—picnics along the
New England shore or Sunday walks
with children rolling hoops in Central
Park. This Boston artist began his
career as a book designer and illustra-
tor before traveling to Paris in the
mid-1890s. His later Venetian water-
colors often depict a famous location,
such as a piazza or bridge, but often
these sights merely form a backdrop
for the colorful parade of visitors.

The Stanford watercolor of St.
Mark's clock tower is unusual because
the architecture, not the people, is the
focus. Painted on his second and last
trip to Venice, it is almost identical to
an earlier view of 1898–99. In both
watercolors the tower looms large,
close to the picture plane, with its
many-tiered structure rendered as a
decorative pattern. The predominat-
ing blues and golds are echoed in the
Arts-and-Crafts-style frame his
brother Charles made the next year.

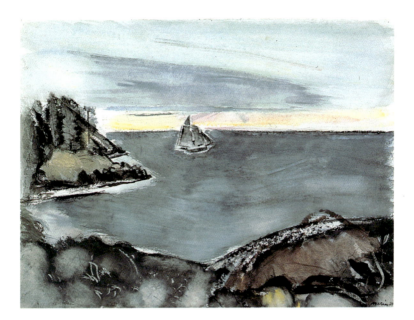

John Marin (United States, 1870–1953)
Boat, Sea, Land, Maine, 1934
Watercolor, 15½ × 20½ in. (393 × 520 mm)
Committee for Art Fund 1982.189

John Marin had visited and painted the Maine coast for twenty years before purchasing property at Cape Split in 1934, where this watercolor was made. After the high energy of his earlier New York scenes, the rocky coast of Maine with its pine trees and little coves offered a more peaceful subject. In contrast to the vigorously brushed browns and blues of the rocky coast and open water, Marin has tinted the sky with pale pink and yellow washes, suggestive of a gentle dawn. Marin's Maine coast views do not include crashing waves or wrecks, and they lack Winslow Homer's focus on the strong people of the sea. In their place, a distant sailboat appears in many of Marin's views; it serves as a metaphor for man's small place in nature.

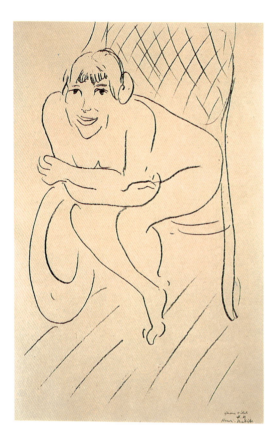

Henri Matisse (France, 1869–1954)
Nude Seated in a Wicker Chair, 1913
Transfer lithograph, inscribed trial proof,
19¼ × 11 in. (490 × 280 mm)
Gift of Mrs. Michael Stein 1953.606

Sarah Stein
is wife
of Michael
Stein brother
to Leo & Gertrude

This lithograph by Matisse is one of twelve prints that Sarah Stein gave to Stanford during the years she lived in Palo Alto after she and her husband, Michael (brother of Gertrude and Leo), returned from France in 1935. Sarah, whom Matisse considered the really intelligent member of the family, had studied drawing with the artist, and it is tempting to think that some of the lithographs she presented to Stanford had been given to her by Matisse, perhaps when he visited California. Ranging in date from 1913 to the late 1920s, the early prints are of nude studio models, while the later ones include several portraits of the artist's daughter Marguerite dressed in a feminine organdy dress or ruffled blouse.

For Matisse, drawing from the female nude was a lifelong joy and discipline. In his early lithographs, such as this one, he presents the figure in a relaxed but engaging pose, summarily indicated in long, fluid strokes that isolate it from the background.

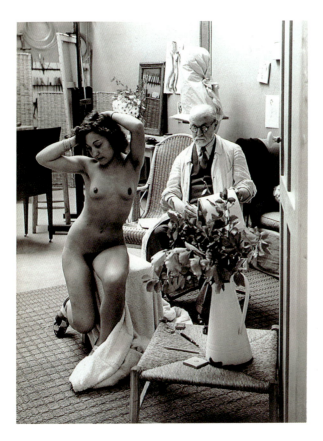

Gyula Halász, called Brassaï (Hungary, 1899–1984)
Matisse Drawing a Nude Model at the Villa d'Alsesia, 1939
Gelatin-silver print, 14¹/₁₆ × 10½ in. (359 × 268 mm)
Committee for Art Fund 1982.330

Brassaï went to Paris in 1924 to work as a journalist. There, André
Kertèsz, another Hungarian expatriate, persuaded him to try photog-
raphy, and in the early 1930s Brassaï began to take pictures for both
his own books and the publications *Minotaure* and *Harper's Bazaar*.
Brassaï concentrated on two types of subject matter: the people and
places of after-hours Parisian nightlife, and artists and writers, all of
whom he portrayed with a directness that is neither sensationalist nor
overly sentimental.

Since Brassaï was also a sculptor and draftsman, his photographs
of artists, such as this one of Henri Matisse, evince respect and empa-
thy for the work of the artist. Here the physicality of a live model
creates a secondary subject for the photographer.

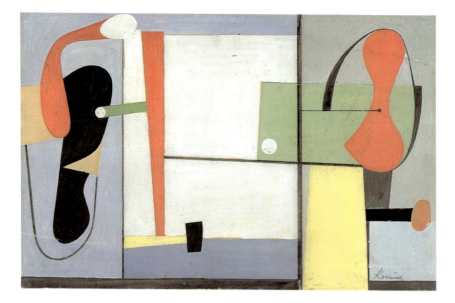

Willem de Kooning (United States, b. 1904)
Design for a Mural, 1935
Gouache, 9⅜ × 14⅜ in. (237 × 365 mm)
Bequest of Dr. Harold C. Torbert (A.B. 1929, M.D. 1933)
and his wife, Frances Burger (A.B. 1929) Torbert 1984.510

This lyrical and witty drawing is a rare example of de Kooning's
early work. Having left Holland to settle in New York, he was one of
Fernand Léger's assistants on a mural for the steamship company the
French Line and also one of several abstract artists commissioned for a
Works Progress Administration housing project in Brooklyn. The
Stanford design, one of three for the Williamsburg Housing Project,
shows both the bright colors reminiscent of Léger and the firm
compositional balance suggestive of Mondrian. The two quasi-
biomorphic forms also reveal the close relationship of de Kooning
with his friend Arshile Gorky. In the late 1980s the artist returned to
the light palette of this design, but unlike the tight construction of
the early work, isolated gestures appear in the late compositions.

Mark Tobey (United States, 1890–1971)
Untitled, 1964
Gouache, 11 × 8½ in. (282 × 218 mm)
Gift of Dr. Ralph Spiegl (A.B. 1945, M.D. 1948) 1965.74

Tobey's work has often been compared with that of Paul Klee. Music and literature were important for both artists, each of whom drew from diverse sources in formulating his highly personal imagery. Each worked on a small scale in experimental and complex techniques. Tobey might have been speaking about the Stanford sheet when he wrote "of covering a surface completely," and that "everything stirs, everything moves, everything becomes animated, . . . that there was no such thing as empty space. It's all loaded with life."

Tobey is represented in the Museum's collections by more than a dozen works on paper, from a figure study of 1939 to a group of abstractions from the mid-1960s, the period when he achieved international recognition. Many of these were given by Joyce Lyon Dahl who, with her husband Arthur, was a close friend and major patron of the artist.

Imogen Cunningham (United States, 1883–1976)
Edward Weston and Margarethe Mather, 1923
Gelatin-silver print, 7⅜ × 9⅛ in. (186 × 234 mm)
Museum Purchase Fund 1972.117.3

Imogen Cunningham met Edward Weston in Glendale, California, in 1923 when they were both working in the soft-focus style of the pictorialist movement. Yet this double portrait, taken in Weston's studio with one of his lenses, hints at the sharper focus that became popular in the next decade. Cunningham and Weston were founding members of f/64, a group of West Coast photographers who used a straightforward, unmanipulated technique.

Margarethe Mather was Weston's partner and assistant in his Glendale studio. It was she who persuaded Weston to use his camera to capture what he saw, as he saw it, not as an idealized depiction of what he wanted to see. Through their relationship Weston gained entry to Mather's circle, which included writers, painters, and musicians from the bohemian circles of Los Angeles.

Leo Holub (United States, b. 1916)
San Francisco from Red Rock Hill, 1972
Gelatin-silver print, 12⁷⁄₁₆ × 18⁷⁄₁₆ (317 × 468 mm)
Gift of the artist 1975.69

For many years the hills of San Francisco have provided sweeping panoramas to delight artists and tourists alike. Almost a century before this photograph was taken, Eadweard Muybridge made his famous 360-degree panorama of the city from the California Street hill. Holub's picture updates its nineteenth-century predecessor by capturing the familiar landmarks of San Francisco in the almost palpable light. The atmospheric quality of the picture makes the cityscape seem like a banner billowing in the wind, between the dark hills below and the downy clouds above. Now almost twenty years old, Holub's photograph documents a skyline that no longer exists.

Initiating the photography program at Stanford, Leo Holub served on the art faculty from 1970 to 1980.

Robert Frank (United States, b. 1924)
New York City, 1960
Gelatin-silver print, 12⅝ × 8⅜ in. (322 × 212 mm)
Gift of Raymond B. Gary 1984.493.97

Born and educated in Zurich, Robert Frank has been one of the keenest photographic observers of the American social landscape since World War II. After moving to New York City in 1947 and working for *Harper's Bazaar*, *Fortune*, *Life*, and *Look* magazines, he applied for a Guggenheim Fellowship in 1955. With the grant money he bought a car and traveled across the country, photographing scenes of popular culture, such as picnics, parades, and downtown thoroughfares. In 1958 a selection of the results was published in Paris in his book *Les Américains*, and an American edition appeared the following year. Like his coworker at *Fortune*, Walker Evans, Frank strove for a stark realism that was initially denounced by critics. In 1959 Frank began making films. Part of a special collection of 157 prints, this image is one of more than one hundred unpublished Robert Frank photographs that the Stanford Museum received as a gift in 1984 from Bowen H. McCoy (A.B. 1958) and Raymond B. Gary.

Jasper Johns (United States, b. 1930)
0-9, 1960
Lithograph, 24⅝ × 18⅞ in. (625 × 480 mm)
Gift of Anita and Robert Mozley 1978.228

Gifts of lithographs by Jasper Johns and Roy Lichtenstein brought into the Museum collection contemporary examples of the medium, which was already represented by strong nineteenth-century holdings. Commonplace objects like these stencil numbers constitute a major area of exploration in Johns's work. The artist has variously arranged numerals singly, superimposed, or densely massed. His many prints of the 1960s and 1970s range from the very small to the large dimensions of this impressive lithograph and from muted aquatinted grays to brilliant rainbow hues.

0-9, among his earliest lithographs, was done at Tatanya Grosman's Universal Limited Art Editions (ULAE) studio on Long Island. One feels the pressure of the artist's hand drawing directly on the stone—in the tradition of great lithography—responding to accidents, rubbing out, and making changes.

Helen Levitt (United States, b. 1918)
Untitled, 1971
Dye-transfer print, 13¹⁵⁄₁₆ × 9¹⁄₁₆ in. (355 × 232 mm)
Committee for Art Fund 1989.55

Helen Levitt began photographing street life in New York City in 1936. Since then she has made pictures of many aspects of urban life, but her photographs of children have received the most attention. She captures her subjects in an unforced yet aesthetically potent manner, which can be traced to her admiration for Henri Cartier-Bresson and what he termed the "decisive moment."

Levitt has worked with a variety of media, beginning with black-and-white photography, moving on to film, and then working in color photography. Her color images are characterized by their vibrancy, which is evident in the Stanford scene, where the children's clothing, the gumball machine, the fruit piled in the window, and perhaps above all, the brilliant blue of the building act as counterpoint to the otherwise bleak environment.

Lorie Novak (United States, b. 1954)
Untitled, 1983
Type-C print, 14¼ × 14³⁄₁₆ in. (362 × 361 mm)
Gift of Mack Novak 1985.228

Lorie Novak studied photography at Stanford with Leo Holub and received her B.A. in 1975; she is currently teaching at New York University in the Department of Photography, and her work has been widely exhibited. Her experiments with multiple-image photography began in 1979 by projecting colored light on objects and walls in furnished interiors. This led to the projection of old color slides made by her, her family, or other people she knew. Acting as set designer, she thus transformed the rooms in which she worked into a kind of theatrical space. The resulting images are of two types: one emphasizes formal rearrangement through spatial dislocations; and the other concentrates on the visual and psychological relationship of past events to present experiences. Novak has invented a technique that is both self-referential (i.e., photographs about photographs) and emotionally complex. She has created a kind of photography that strives to encapsulate in a single image the compression of time and space usually treated in fiction, theater, and cinema.

Nathan Oliveira (United States, b. 1928)
Santa Fe Wing No. 9, 1987
Watercolor, 26⅞ × 40¼ in. (680 × 1022 mm)
Gift of the Stanford Centennial Committee
on the occasion of the 100th anniversary
of the founding of the University 1990.27

Nathan Oliveira, Ann O'Day Maples Professor of Art, has taught at Stanford for more than twenty years. Active as a printmaker, painter, and sculptor, Oliveira was part of the Bay Area Figurative group and a leading force in the national revival of the monotype in the early 1970s.

On his walks in the Stanford hills, where he has a studio, Oliveira has observed the red-tail hawk soaring on updrafts, "so aloof and detached, yet aware of what's happening below." Oliveira had earlier painted small oils and watercolors, as well as made monotypes of falcons and hawks, but since 1985 he has concentrated on large watercolors of a single wing, a metaphor of freedom. "We must enter the twenty-first century on the wings of our intelligence and our concern for civilization. It will happen in this place, in our second one hundred years."

Mark Tobey: Works on Paper. Introductory essay by Paul Cummings; essay by Judith S. Kays; catalogue by Betsy G. Fryberger and Judith S. Kays, 1990. 55 drawings and monotypes. 24 pp., 17 illus., 6 color pls. $7.50.

Sean Scully/Donald Sultan: Abstraction/Representation. Essay, checklist, and chronologies by Michelle Meyers, 1990. 30 pp., 10 illus., 8 color pls. $6.95.

Twentieth-Century Drawings from the Anderson Collection: Auguste Rodin to Elizabeth Murray. Essay and checklist by Caroline A. Jones, 1988. 59 drawings. 32 pp., 22 illus., 10 color pls. $7.50.

The Anderson Collection: Two Decades of American Graphics, 1967–1987. Prints, Multiples, Monotypes, and Works on Paper. Essay and checklist of 160 works by 50 artists by Betsy G. Fryberger, 1987. 24 pp., 14 illus. With two additional publications from the Anderson collection: *Selected Prints by Robert Motherwell,* 1986. *Selected Prints by Richard Diebenkorn,* 1987. All three, $7.50.

The Ikeda Collection of Japanese and Chinese Art at Stanford. A history of the remarkable Asian collection acquired by Jane Stanford from the Baron Ikeda by Patrick J. Maveety, 1987. 16 pp., 15 illus., 3 color pls. $4.00.

Museum Builders in the West: The Stanfords as Collectors and Patrons of Art, 1870–1906. By Carol M. Osborne, with essays by Paul Venable Turner, Anita Ventura Mozley, and a note by Mary Lou Zimmerman Munn, 1986. 138 pp., 172 illus., 7 color pls. Funded by the National Endowment for the Humanities. $9.95.

Gwen John: Paintings and Drawings from the Collection of John Quinn and Others. Essays by Betsy G. Fryberger and Cecily Langdale; catalogue entries by Fryberger and Langdale, 1982. 13 paintings, 30 drawings and watercolors. 64 pp., 43 pls. plus 18 figs., 4 color pls. $10.00.

Eighteenth-Century Italian Prints from the Collection of Mr. and Mrs. Marcus S. Sopher with Additional Works from the Stanford University Museum. Catalogue by Claudia Lazzaro, 1980. 132 prints. 62 pp., 23 illus. $3.50.

In Celebration of Paul Klee: Fifty Prints. Collector's preface by Carl Djerassi; essay by Charles W. Haxthausen; chronology and catalogue by Betsy G. Fryberger, 1979. 50 prints. 188 pp., 61 illus., 4 color pls. $10.00.

Seventeenth-Century Italian Prints from the Collection of Mr. and Mrs. Marcus S. Sopher. Catalogue by Marcus S. Sopher with Claudia Lazzaro-Bruno, 1978. 179 prints. 232 pp., 179 illus. $10.00.

Whistler: Themes and Variations. Introduction by Lorenz Eitner; catalogue by Betsy G. Fryberger, 1978. 62 prints, 8 drawings, 3 pastels, 7 watercolors, 5 paintings. 81 pp., 86 illus., 5 color pls. $6.50.

The Founders and the Architects. Foreword by Lorenz Eitner; essays on the design of Stanford University by Paul V. Turner, Karen Weitze, and Marcia E. Vetrocq, 1976. 104 pp., 84 illus. $8.00.

Drawings by Richard Diebenkorn. Essay by Lorenz Eitner, 1965, reprinted 1978. 59 drawings. 62 pp., 59 illus. $5.00.

The Stanford Museum, a biennial journal, includes essays on notable additions to the collection, lists of acquisitions, and a summary of exhibitions. The current issue, 1988–89, commemorates the tenure of Lorenz Eitner as director from 1963 to 1989. It includes essays on major donors and the formation of the Museum's collections. Copies are available from the years 1973 to the present. $5.00.

To order any of the above, please contact the Stanford University Museum of Art, Lomita Drive and Museum Way, Stanford, California, 94305-5060.